The Beginner's Guide

The Female Nude

A complete step-by-step guide to techniques and materials

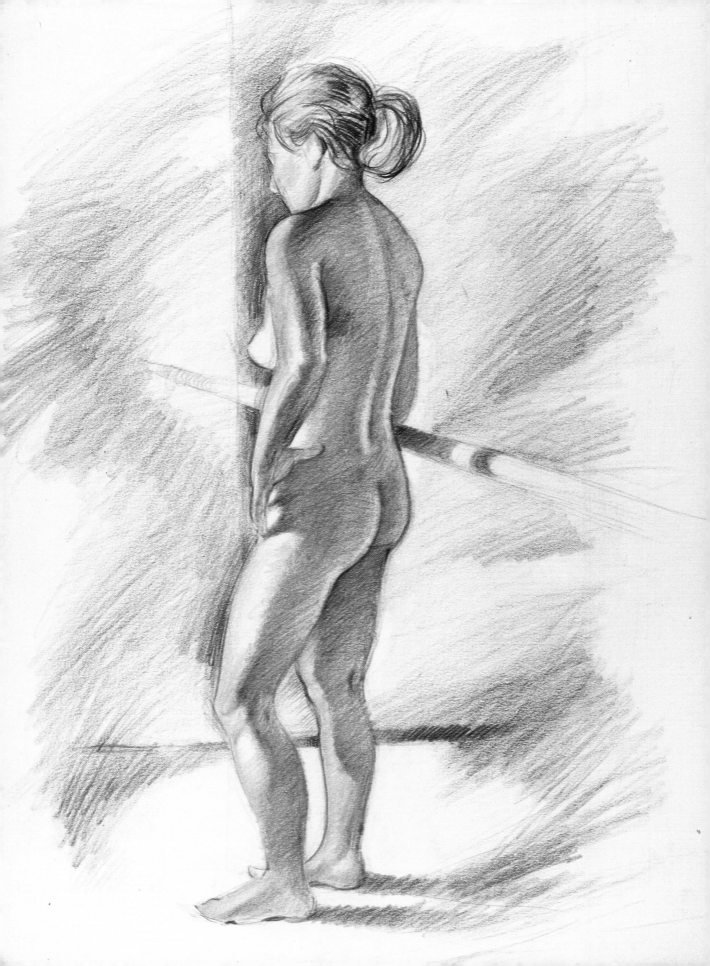

The Beginner's Guide

The Female Nude

*A complete step-by-step
guide to techniques and
materials*

IAN SIDAWAY

NEW
HOLLAND

First published in 2000 by
New Holland Publishers (UK) Ltd
London • Cape Town • Sydney • Auckland

24 Nutford Place
London W1H 6DQ
UK

80 McKenzie Street
Cape Town 8001
South Africa

Level 1, Unit 4, 14 Aquatic Drive
Frenchs Forest, NSW 2086
Australia

Unit 1A, 218 Lake Road
Northcote, Auckland
New Zealand

10 9 8 7 6 5 4 3 2 1

ISBN 1 85974 166 5

Designed and edited by
Axis Design Editions Limited
8 Accommodation Road
London NW11 8ED

Managing Editor: Jo Wells
Project Editor: Kim Davies
Art Director: Siân Keogh
Art Editor: Sandra Marques
Photographers: David Jordan and Nicola Jordan

Reproduced by Colour Symphony in Singapore
Printed and bound in Singapore by Craft Printers (PTE) Ltd

ACKNOWLEDGEMENTS
Special thanks are due to Daler-Rowney,
P.O. Box 10, Bracknell,
Berkshire, RG12 4ST
for providing the materials and equipment featured in this book.

C ONTENTS

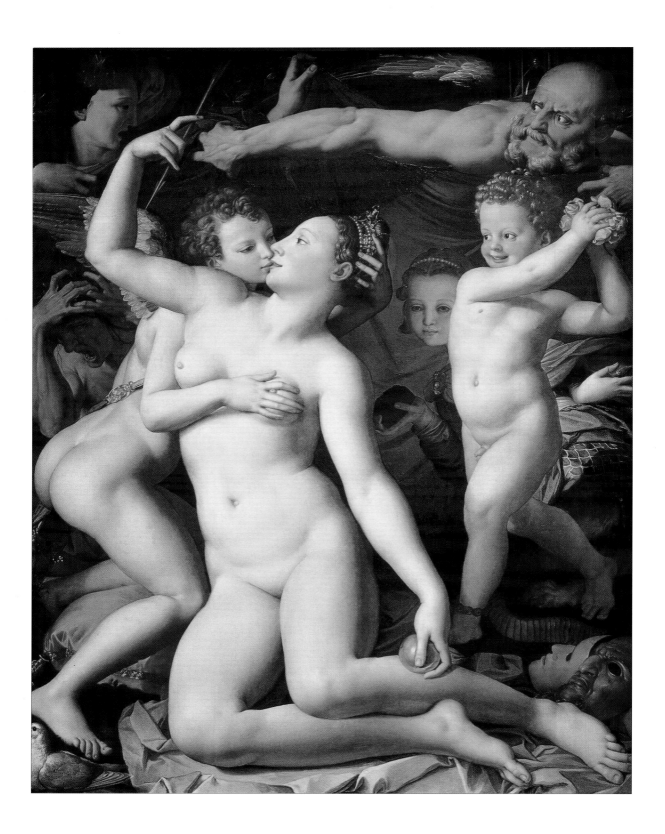

INTRODUCTION

The naked female form has moved man to creativity as far back as Palaeolithic times. Throughout Europe and Russia naked female figures, known as Venuses, have been found scratched into cave walls.

In the art of the ancient civilisations the human image is idealised – almost without exception men and women are depicted as youthful, following strict representational conventions. This preoccupation with the idealised human form is most evident in the art of ancient Greece and Rome. In sculpture, painting and the decorative friezes around pots and amphorae, the figure was always depicted as possessing a perfect athletic physique. However, the female figure appears relatively rarely.

The female nude was not a subject to be dealt with during the dark days of war and religious guilt of the early medieval ages. But with the Renaissance in 15th century Italy, art took a giant leap forward. Anatomical

Venus, Cupid, Time and Folly *c*1540–1560
Agnolo Bronzino 1503–1572

This allegorical painting on the subject of love places its erotic subject matter in a classical setting, and so was seen as acceptable.

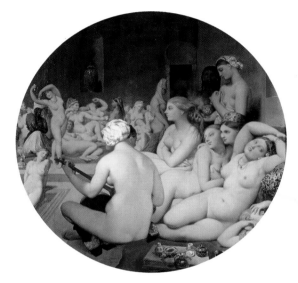

La Source 1856
Jean Auguste Dominique Ingres 1780–1867

Ingres planned this painting, a blatant celebration of the female nude, for many years before it was painted. The central figure appears in an earlier work, Baigneuse de Valpincon.

investigations by Antonio Pollaiuolo (*c*1432–1498) and Leonardo da Vinci (1452–1519), and a greater understanding of perspective, made it possible for artists to treat the figure more objectively, and to create the illusion of three dimensions by positioning the figure convincingly in a two-dimensional space.

Armed with this new knowledge, artists turned once more to the legends of classical antiquity and the female nude was increasingly used as a subject to invest paintings with emotive power and intensity, appearing in many works by such great painters as Michelangelo (1475–1564), Raphael (1483–1520), Botticelli (1445–1510), Titian (*c*1487–1576) and Tinteretto (1518–1594).

But whilst the nude was used in works by artists as diverse as Rembrandt (1606–1669) in Amsterdam, Tiepolo (1696–1770) in Venice, Velazquez (1599–1660) and Goya (1746–1828) in Madrid, and Ingres (1780–1867) and Delacroix (1798–1863) in Paris, its acceptability relied on its being seen in a classical or mythological context. The naked portrait of a real person was rare. Examples are Helena Fourment as Aphrodite by Rubens, and François Boucher's painting of Louise O'Murphy commissioned by Casanova.

The later work of Ingres can be seen as something of a watershed, with two paintings, although popular, raising a degree of controversy. Both are overt celebrations of naked femininity. These were *La Source*, 1856, and *Le Bain Turc*, 1862.

In 1863, French artist Edouard Manet (1832–1907) caused a storm of controversy when he exhibited *Le Dejeuner sur l'Herbe* at the Paris Salon des Refuses. The picture, showing two fully dressed men seated with a

Olympia 1863
Edouard Manet 1832–1883

This painting, Manet's reinterpretation of the theme of the reclining Venus, painted so many times before, raised more controversy than all the others because it showed her as a prostitute.

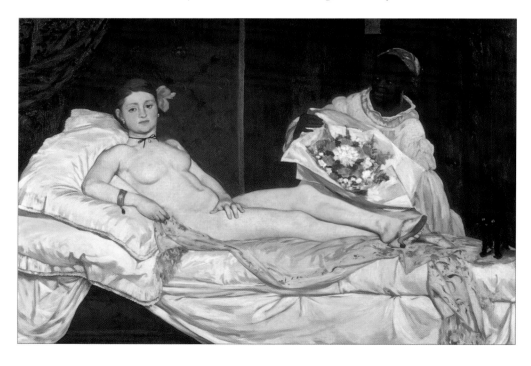

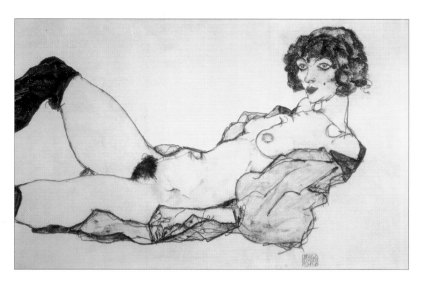

naked woman, was seen as scandalous. In 1865 Manet exhibited *Olympia* to critical and public outrage, rooted in the fact that the model, Victorine Meurent, who appeared in many of Manet's pictures, was obviously representing a prostitute.

This image of the female nude in real-life situations gained impetus with the pastel works of Edgar Degas (1843–1917) and the oils of Auguste Renoir (1841–1919), both of whom produced a large body of work showing the nude female bathing or at her toilet. Criticism was now more about technique than content. Renoir and Degas were respected artists and when their pictures of female nudes appeared, a decade after *Olympia's* unveiling, public opinion had sobered.

Degas' bathers showed the female nude going about her toilet apparently unposed and oblivious to the artist and onlooker. These were truthful representations of the female nude, used as a means to explore and experiment with the imagery and problems of composition, colour and technique.

Reclining woman with green stockings 1914
Egon Schiele 1890–1918

Drawn towards the end of his short life, this work shows the economy of line and colour with which Schiele was able to capture the pose.

This raw approach is perhaps seen best in the superb drawings and paintings made by the Austrian artist Egon Schiele (1890–1918). His works, although often erotic, disturbingly contorted or pornographic, were superbly drawn. Schiele's main strength was his use of line which searched out the figure's form with a startling fluid simplicity.

The 20th century has seen a huge diversification in artistic direction and discipline. Depictions of the female nude still abound, and looking at paintings by Picasso, Stanley Spencer, De Kooning, Wyeth, Philip Pearlstien or Lucien Freud gives an idea of their diversity. The female nude is still a primary subject to test the artist's techniques and powers of representation.

MATERIALS AND EQUIPMENT

The choice of drawing and painting materials is infinite. Only by experimenting with different media and surfaces can you decide on, and begin to develop, a style that you feel expresses your personal creativity.

Art stores for the artist are like a sweet shop to a child, full of good things demanding to be purchased. Art materials are expensive, however, and it is easy to buy more than are really needed. A good tip is to avoid buying sets of things, desirable as they might seem, as invariably you will find that certain colours are never used. The same is true of paper, especially watercolour and pastel papers. If you buy a block of several sheets you may find that the paper does not suit you or your subject; far better to buy individual sheets until you find one or several different sheets that you like.

CHARCOAL

Charcoal is simply charred wood heated in a controlled environment with a little oxygen to prevent it from burning completely. The best charcoal is made from the beech, the vine and the willow. It can be purchased in varying degrees of thickness. Thin sticks are available in boxes of several sticks, while thicker sticks can be purchased individually. Very thin sticks shatter easily and so demand a certain lightness of touch; the thicker sticks can be quite hard and used with more vigour. Wrapping a small piece of tin foil around the part of the stick held in the hand helps keep the hand clean. Sticks can be sharpened with a craft knife or rubbed on sandpaper.

Charcoal sticks and pencils made from compressed charcoal are also available. These are harder and encased in wood or found as short dumpy sticks. They are often graded in hardness like pencils. They are cleaner to use than stick charcoal but the line tends not to have quite the same fluid quality.

Charcoal can be blended in many ways but a useful tool for doing this, and one which you can also use when working with pastel, is the paper torchon. This is a tight roll of paper drawn to a point which is used to push charcoal dust around the paper, altering the tone and blending or softening lines.

Charcoal is an ideal material for working in bold strokes. With it you can produce a wide range of tones, from deepest black to the most subtle of shades.

If you find using charcoal sticks too messy you can buy charcoal pencils, which can be easier to use.

PENCILS, GRAPHITE PENCIL/STICKS AND COLOURED PENCILS

The "lead" pencil is made from a thin graphite strip encased in wood to protect it and to make it easier to hold. The wood case can be round or six-sided.

Pencils are graded according to hardness. The scale runs from 8H, the hardest, down to H, F, HB and B, then up to 8B, the softest. Avoid dropping pencils, especially in the softer range, as the graphite strip can shatter making it next to impossible to sharpen them.

Studio pencils have a rectangular graphite strip. These are useful for quickly laying in areas of tone.

Better still are graphite pencils and sticks. Graphite pencils are simply solid thick strips of graphite and are graded in hardness like pencils. They have the added advantage of making not only fine lines but also, when the pencil is used at an angle so that more of the pencil comes into contact with the paper, broad areas of tone. Graphite sticks are used in much the same way but are dumpy and thicker. Whilst pencils are best sharpened with a sharp knife, graphite pencils are more easily kept sharp with a pencil sharpener. As with pencils, try to avoid dropping them on the floor. It is important to take great care when using very soft graphite pencils as, if held too far up the shaft whilst applying pressure, they can break. Graphite is also available as a fine powder which can be spread over and worked into the paper with the finger or using a torchon.

As with ordinary pencils the strip in coloured pencils is encased in wood in order to protect it. Made from pigment, binder and lubricant to make the crayons move smoothly across the support, they have a slightly waxy feel to them. The range of colours to be found is quite wide.

ERASERS, KNIVES AND FIXATIVE

Erasers can be found in a multitude of forms. The best are the

Coloured pencils are generally sold in boxed sets, although they are also purchased individually. There are a number of different qualities, but it is advisable to buy the best that your budget will allow.

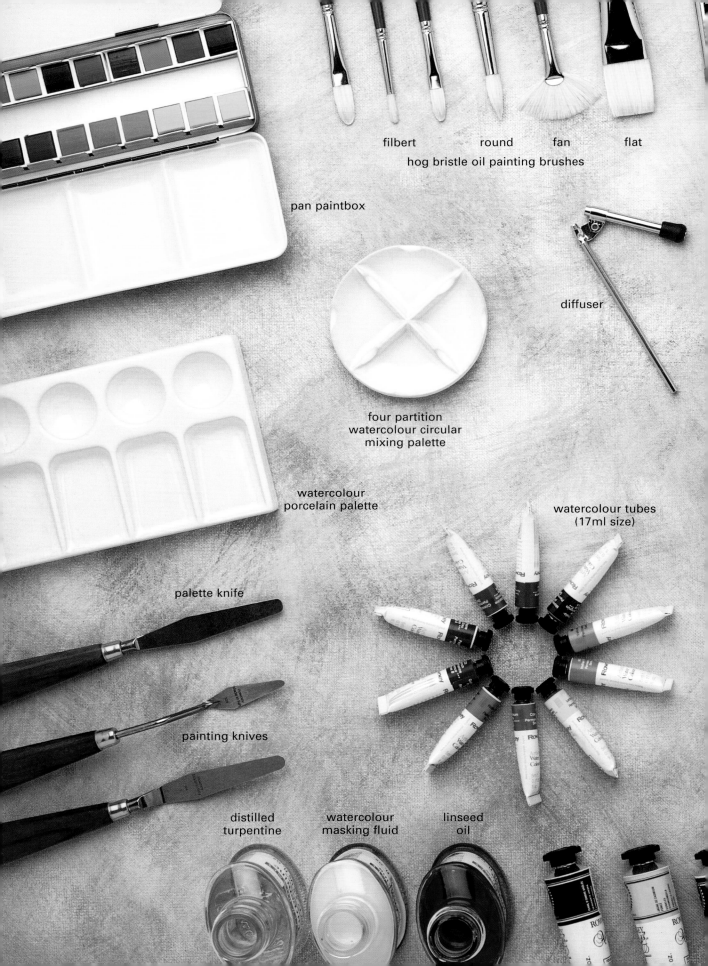

filbert round fan flat

hog bristle oil painting brushes

pan paintbox

diffuser

four partition
watercolour circular
mixing palette

watercolour
porcelain palette

watercolour tubes
(17ml size)

palette knife

painting knives

distilled
turpentine

watercolour
masking fluid

linseed
oil

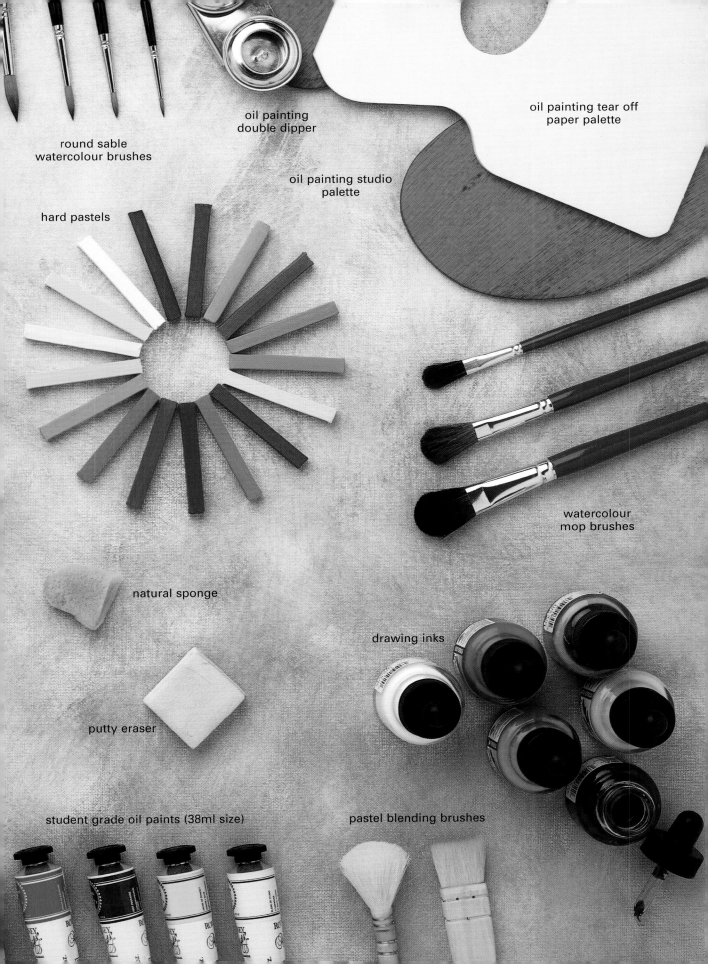

round sable
watercolour brushes

oil painting
double dipper

oil painting tear off
paper palette

oil painting studio
palette

hard pastels

watercolour
mop brushes

natural sponge

drawing inks

putty eraser

student grade oil paints (38ml size)

pastel blending brushes

softer so-called putty erasers. These are kinder to the paper surface and have the advantage that they can be moulded to a point. They can get dirty very quickly so when erasing a particularly dark area, cut a piece of the eraser off and use it. This will keep your eraser cleaner for longer. Whichever eraser you choose, it is important not to think of it just as a means to make corrections. Use it to add texture or lighten tone and, by working through an area of tone to expose the white paper, as a drawing implement itself.

A good craft knife is invaluable; even better, have two, a smaller fine one and one such as a retractable knife found in DIY stores for heavier work. Pencils, crayons, charcoal and pastels can all be sharpened better with a sharp knife.

Fixative is needed to prevent any drawings that use soft pencil, graphite, charcoal or pastel from smudging. Remember when fixing a drawing before it is finished, that the fixed part cannot then be erased. This can be an advantage, as it enables complex areas of texture to be built up. Fixative can be bought in bottles and used with a diffuser, or you can buy an aerosal spray, which is easier to use.

Drawing inks, both water-soluble and water-resistant, are sold in a vast range of colours.

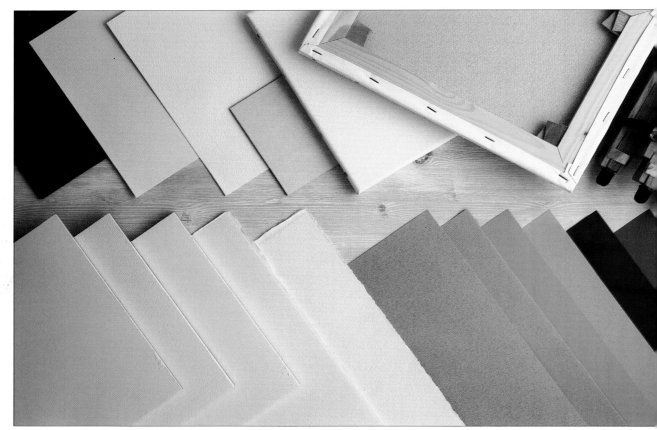

PEN AND INK

Ink is available in a wide range of colours at a modest cost, in either water-soluble or water-resistant form. Water-soluble inks can be thinned with water. They will also soften if rewet, which allows for lines to be lightened or corrections to be made. Combining both types of ink opens the way for a variety of techniques.

Ink is traditionally applied with a dip pen. The pen body is made from wood or plastic, and different sizes and shapes of nib can be used. Traditional feather quill pens make a very distinctive and attractive line, or try a bamboo or reed pen for a different and equally distinctive effect.

Watercolour brushes can also be used with ink. Clean the brushes thoroughly or the dry ink will ruin them.

PASTELS

Pastels are dry pigments that are mixed with a binder to hold them together. They are available, depending on the manufacturer, in three qualities: hard, medium and soft. The range of colours which are available from various manufacturers,

Papers and boards come in a wide variety of weights and colours, and it is important to choose the correct one for the medium you are using. This is especially true for watercolour papers; light- or medium-weight papers can buckle when wet, so it is worth spending time stretching them before use.

reaches into the hundreds. This huge range of colours is needed because pastels are usually worked onto the support as neat colour; a certain amount of blending by finger or with a torchon or blending brush always happens but the works that have the most life and sparkle are those where the least blending has taken place.

The largest range available is for soft pastels; each colour is available in a range of tints making it possible to match most colours. The harder pastels are usually square in shape and it is possible to sharpen these. The range of colours is smaller but they can be used alongside soft pastels and tend to be a little easier to use. Pastel crayons or pencils have a hard coloured pastel strip. The range

More durable than soft pastels, hard pastels contain more binder giving them the advantage of being easy to sharpen with a knife. They are ideal for more precise work such as the initial drawing stage, in which you need to define your composition, and adding the fine details to finish your painting.

of colours is limited but again they can be used alongside traditional pastels and are better for detail and fine work. All pastels can be purchased individually so a range of colours can be acquired to suit the subject matter. To keep loose pastels clean, place them in a jar or box half full of rice. When you shake the jar or box, rice rubs on the dirty pastels and cleans them.

WATERCOLOUR

When buying watercolour paints, buy the very best that you can afford. If you have ever used cheaper paint, you will have noticed the difference. Watercolour paints are available as pans, half pans, tubes and as liquid colour, which is most often used by illustrators. It is not necessary to have lots of different colours and by working with a limited palette you will learn more about colour mixing.

A good range of colour to start with would be cadmium red, alizarin crimson, cadmium yellow, lemon yellow, yellow ochre, cerulean blue, ultramarine blue and Payne's grey. If you wish, you could add viridian and sap green, burnt umber and burnt sienna. Whether to buy pans or tubes is a personal choice. Pans are more economical as less paint is wasted.

Tubes of watercolour are small (5ml). Larger tubes are available, but even the small tubes go a long way. The paint will keep for a long time provided you keep the cap securely screwed on between uses.

Various additives can be bought to mix with the paint. Some will extend drying time, add texture, intensify colour or cause the colour to granulate. White gouache is sometimes used to give watercolour body and make it opaque. It's also worth buying a bottle of art masking fluid to protect parts of the paper you don't want to paint.

A range of different metal or wooden boxes can be bought to hold your paints but remember that you will almost certainly need more colours at some point, so make sure your box is large enough for them.

Watercolour brushes are made from synthetic hair or sable. Sable brushes are expensive but last longer than synthetic ones. Perhaps three round sables, a no. 2 or 3, a no. 6 or 7 and a larger no. 10, together with a couple of flat wash or mop brushes and a natural sponge, are all that should be needed.

Pans are easy to carry around because you simply slot the colours you require into your paintbox. If you prefer pans, buy an empty pan palette and buy the colours you intend to use.

OIL PAINT

Oil paint, like watercolour, can be bought in a range of colours, and, as with watercolour, using a limited palette will not only teach much about colour mixing but will be economical. Paint can be bought in a range of tube sizes and also in tins. Unlike watercolour, where buying the best is advised, student quality oil paint is quite satisfactory. However you will notice that artists' quality is smoother, and the colour stronger and more intense. Cadmium red, alizarin crimson, cadmium yellow, lemon yellow, yellow ochre, ultramarine blue, cerulean blue,

viridian green, ivory, black and titanium white would be a good starter palette. You could add to this sap green, raw umber and burnt umber together with Payne's grey at a later date.

The range of oil brushes is vast. Good quality bristle brushes are best. The main shapes are round, flat, fan and filbert, a flat brush which tapers to a slight point. They give a good repertoire of strokes. The size of brush you choose will depend to a degree on the size which you intend to work. Painting knives come in various shapes to give a range of marks, while a palette knife is handy for cleaning palettes and mixing paint.

Oil paint is thinned with thinners such as turpentine or white spirit. A bewildering range of paint mediums and oils, including linseed oil, are also used. Some are used for glazing, some for impasto work (applying the paint very thickly) and others to speed up the drying time. Palettes for mixing paint are flat, made from plastic

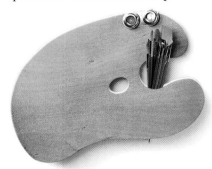

The traditional studio palette is a valuable aid in that it helps the painter keep all that he or she requires to hand.

or wood, and vary in shape and size. A double dipper, which clips onto the palette and holds thinner and oil, is a useful purchase.

SUPPORTS

Each material has its own range of supports. Drawings are usually made on white, reasonably smooth paper; rougher papers can be experimented with and are good when using a broader approach or materials such as charcoal, which can slide on a smooth surface. The same is true of pastel, which needs a slight tooth or texture on the paper in order to deposit pigment. Pastels are more often than not done on a tinted paper which not only works as a mid-tone out of which the painting is worked, but acts to unify the colours. Pastel boards can be bought which have a slight velour feel to the surface and these are pleasant to use.

Watercolour should be done on good watercolour paper. This can be found with three different surfaces: Rough, Not, which has a slight texture and is the easiest to use, and Hot Pressed, which is smooth. All three are available in different weights or thickness. They need to be stretched before use (see page 21), using gum tape (a paper tape whose adhesive is made tacky by wetting). Oils can be used on canvas, textured oil paper and boards. They can also be used on primed hardboard and medium density fibre board (MDF). Canvas and board needs to be primed with acrylic primer (see page 23).

Oil paints come in two different grades: artists' and students'. Artists' colours tend to be more vivid and the colour does not fade with time, but they are more expensive. Students' colours are perfect for practising.

TECHNIQUES

P ainting or drawing, your style will be determined to some extent by the materials and the technique you choose, whether drawing with the fine detail of pencil and pen, or applying the bolder strokes of pastels and oils.

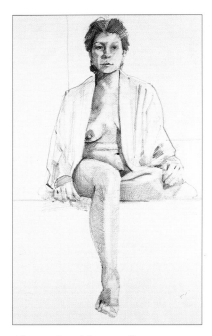

Above Graphite pencil

GRAPHITE PENCIL

The simple graphite pencil is familiar to everyone and is one of the very first mark-making implements we use as children. It is perhaps due to this familiarity that we frequently fail to recognise its wide-ranging potential. Pencil is available in a range of grades from very hard to very soft and the best grades for drawing are the softer grades from HB to 8B.

Pencil is a fast medium. It can also be used to make very considered drawings which build up tone or line slowly. The same is true of the graphite stick, which is simply a pencil with a thick "lead". Another consideration with pencil is that very little equipment is needed to make a drawing. Tone is built up using one of many methods, such as mixing different shading methods together in the same drawing. Here the drawing uses line work and tone, built using scribbled and hatched lines. The tone is then worked on with a putty eraser, knocking it back or lightening it and adding any highlights. Drawings done with soft pencil smudge easily so make sure that you fix them at regular intervals with fixative.

CHARCOAL

Like pencil, charcoal is a quick medium, and is capable of rapidly capturing a pose in line and tone. The possibilities of the material are increased if used with a coloured paper and white chalk, pastel or crayon. Here a mid-grey paper gives a mid-tone out of which the dark charcoal represents the darker tones and the white chalk is

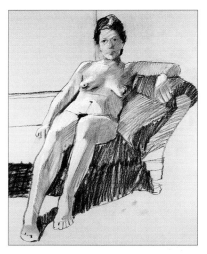

Above Charcoal

used for lighter tones and high-lights. Very seductive drawings can be made using this method, which was often used by the old masters. A variation on this method is known as *les trois crayons*, the three crayons. This involves using black, white and sanguine crayons to produce the dark, light, and mid-tones.

HARD PASTEL

In many respects, hard pastel sticks are similar to charcoal. They are capable of producing a similar quality of line but are cleaner as they "take" more firmly to the paper. This makes them more difficult to erase and tone cannot be laid or erased quite as easily as with charcoal.

By varying the pressure applied to the pastel stick, light or dark lines of varying thickness are easily made; this makes

them ideal for drawings which require strong line work. In reality, lines around people or objects don't exist. Surfaces are seen to change, turn or join one another by altering colour, tone or direction and not by ending with a line. Good line drawings try to show this by having a variety of line density and thickness, which is suggestive of these characteristics.

Here the drawing was first made using a series of light, flowing lines which explored and searched out not only the figure's outline but the internal contours. Once these were seen as correct, some of the lines were redrawn and strengthened in order to suggest both shadow and highlight.

Below Hard pastel

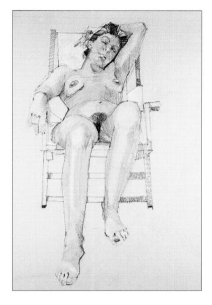

Above Coloured pastel pencil

COLOURED PASTEL PENCIL

Here pastel pencils have been used to produce a drawing which expands on the ideas seen in the charcoal drawing. A paper, the colour and tone of which was sympathetic to the subject, was used to give a light mid-tone base on which to work. Six coloured pastel pencils were then used to lightly draft out the figure and gradually build up the tone and colour, with highlights being added last with a white pastel pencil.

This finished drawing uses a combination of tone and line to successfully describe the form of the figure. Hidden amongst the tone and colour can be seen a few contour lines which give a clue as to the shape and direction of the surface. The same technique can also be used with coloured pencils or soft pastels.

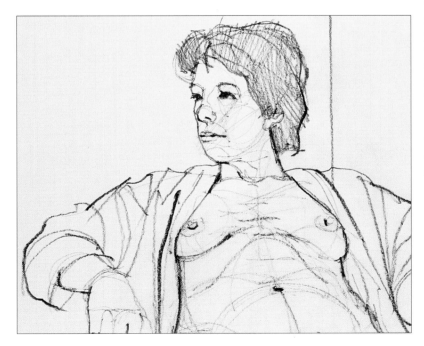

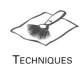

Above *Pencil quick poses*

PENCIL

Pencil makes the ideal medium for making rapid drawings. Any medium which makes a strong solid mark would also be suitable, including charcoal and graphite sticks. Rapid drawings and quick poses serve several purposes: they force you to draw boldly and fluently and they help develop your powers of observation as, given the rapidity with which the model alters her position, the artist is forced to look for those lines and shapes which represent the pose or position with the most economy. Quick poses are also a useful way of limbering up before attempting to draw or paint the figure proper. The model can keep changing the pose after a few minutes or she can be asked to perform a task. Here the model is seen preparing for and drying herself after taking a bath.

PEN AND INK

Good drawings made with a dip pen and ink have a real beauty but they are notoriously difficult to achieve. Pen and ink is an intimidating medium which can be difficult to correct, and if lines fail to flow freely, they can easily look tired and uninspired. If a pen and ink drawing goes wrong and the mistake is not easily disguised or incorporated, it may be better to begin again. Initially when working with the medium, try working over a light pencil drawing. Do not think of this as cheating; it will simply help keep the work moving in the right direction. Try not to follow the pencil lines but redraw using the pencil marks as a guide. Adding water to the ink will lighten it and can make your initial marks less apparent. Once the figure is fully realised, the ink can be used neat and at full strength. If you have used a pencil drawing as a guide, this can be erased once the drawing is complete. Always allow plenty of time for the ink to dry so as not to ruin the drawing by smudging it.

Below *Pen and ink*

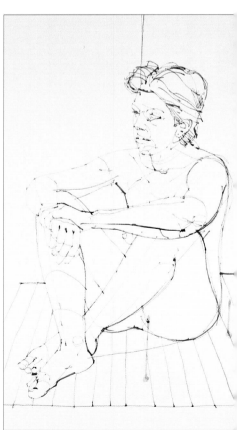

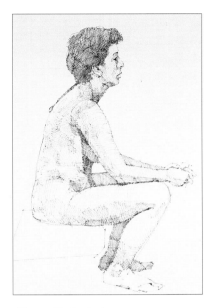

Above Technical pen

The beauty of a dip pen is its ability to make a line that varies in thickness according to the degree of pressure applied to it. Technical pens, biros and some markers make a line of one thickness only. However, these are all capable of making drawings which contain a full range of subtle tone, and lines can appear to alter in thickness by being restated several times. As with the conventional dip pen, mistakes are not easily corrected; working over a light pencil drawing can help. Tone is built up by hatching and cross-hatching a series of lines to build up areas of varying density. The technique is both absorbing and controllable and is capable of producing very subtle drawings. The technique is also valuable because it teaches how to observe the gentle transition of tone from light to dark. Highlights are left as white paper, whilst very dark or black areas are heavily cross-hatched so that little or no white paper can be seen.

SOFT PASTELS

Soft pastels are mixed and blended in one of two ways. Either they are blended on the support using a finger, torchon or blending brush, or the coloured hues are placed next to one another on the support and

Stretching Watercolour Paper

In order to stop watercolour paper buckling and cockling each time it is wet, the paper should be stretched prior to starting work. You need a sheet of watercolour paper, a wooden board larger than the sheet of paper, four lengths of gum strip, water and a sponge.

1
Lay the sheet of paper onto the board and wet it with water using the sponge. Do not rub the paper too hard because it is easily damaged when wet. Remove any excess water with the sponge.

2
Take a length of gum strip and wet it. Lay the strip down one edge of the paper and secure it to the board. Do the same along the other three sides.

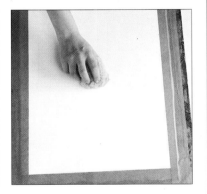

3
Remove any excess water on the paper, making sure all four edges are secure, and place the board to one side. Let it dry thoroughly before starting work.

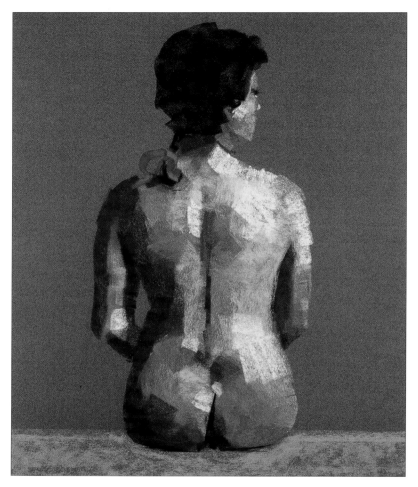

ground which was seen to be sympathetic to the overall colour and gives the work an underlying sense of harmony.

WATERCOLOUR

This is ideally suited for figure painting as the subtle medium is capable of representing the equally subtle transition of colour, tone and light at play on the contours of the naked female figure. Watercolour is usually worked on a white surface, which reflects light back through the layers or washes of paint. Washes are worked "wet in wet" – colours are applied over each other while still wet – or "wet on dry" – each layer is allowed to dry before another is added. A combination of these methods is usually used in any one painting. In this painting of a reclining figure, the lightest tones and colours were applied

Left Soft pastel

Below Watercolour

the mixing takes place optically in the viewer's eye. This was the principle used by the pointillists in the late 19th century. If a limited range of pastel colours are available, this direct approach can result in a very complex work which will enable the marks to keep their freshness and intensity without colours becoming muddy and confused. By fixing between layers of marks the work can be taken to an exceptionally high degree of finish. This simple back view has been done on a coloured

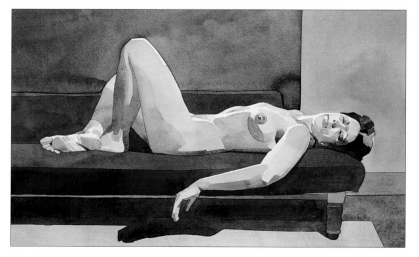

first, with each subsequent colour wash modifying the one beneath. When subtle changes of colour or tone are required, washes are allowed to run together and mix. The darkest colours are painted in last of all. Depending on the paper used, watercolour can be corrected by rewetting areas and blotting off the redissolved paint.

OIL PAINT

Oil paint, despite its reputation to the contrary, can be remarkably easy and clean to use. This small painting was done using only six colours which were mixed with liquin. This is a quick-drying medium and will allow oil paint, which can take up to several days to dry, to be dry enough for overpainting in a few hours. The painting was made quickly on a board prepared with primer and was drawn and painted in under one hour. The painting was then repainted the following day. The figure is seen in the context of a slightly unusual environment, a picture waiting to be painted! An advantage of oil painting is that corrections can be made easily; the wet paint can simply be scraped off and the new paint applied on top. Picture-making possibilities surround us, and unusual ones may crop up several times a day. Keep alert to them and if it proves impossible to produce a picture there and then, make a note of the idea for the future.

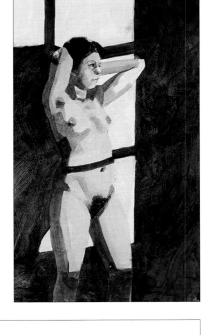

Right Oil paint

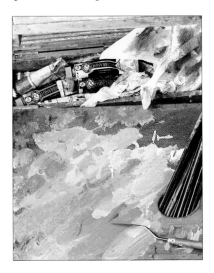

You can buy wooden paintboxes which will keep everything clean and tidy – and in one place!

Priming Canvas and Board for Oil Painting

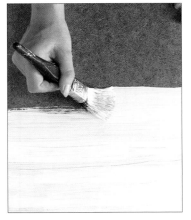

1
If using MDF or the smooth side of hardboard, first key the surface with a sheet of sandpaper. Using an acrylic primer, work across the board or canvas until it is totally covered. Allow to dry thoroughly.

2
Once dry, repeat the process, working the brushstrokes at an angle to the brushstrokes used in the first coat. The process can be repeated several times depending on how smooth the surface is intended to be.

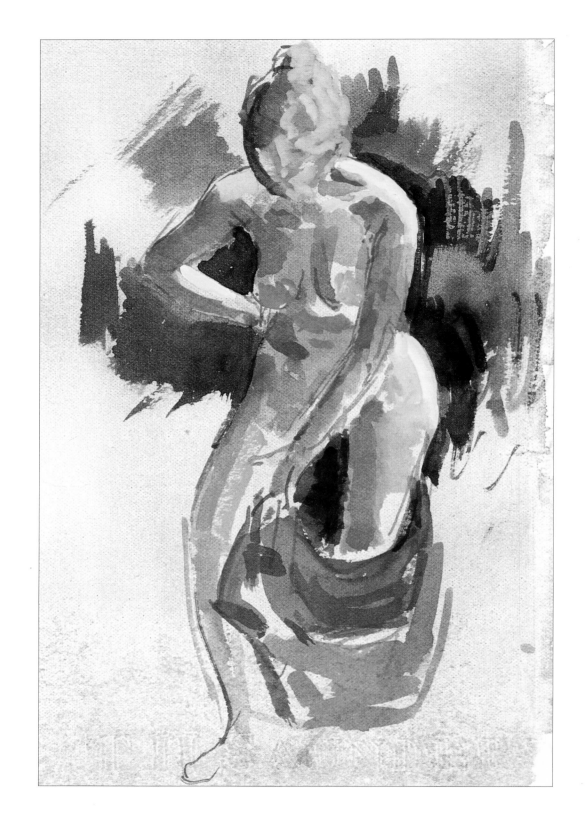

GALLERY

Each medium brings with it not only its own range of techniques but also its own problems of representation. Artists solve these in many ways and this small gallery of drawings and paintings done by different artists with a range of different materials aims to show just a few chosen solutions. The pictures have been selected to demonstrate how choice of material, technique, composition, framing, scale and colour, together with the figure's chosen pose, all contribute to creating a mood and style.

Woman Undressing
James Horton
25 x 18cm (10 x 7in)

Expressive brush work lends a sense of immediacy to this figure caught in the act of removing an article of clothing. Artists often do several pictures at one sitting with the model changing her pose every few minutes. The exercise is excellent practice for honing the artist's powers of observation.

Study of Debbie
David Curtis
25 x 30cm (10 x 12in)

A splash of bright sunlight streaming through a window has been seen as a perfect picture-making opportunity. The shadows cast by the window frame serve to show up the contours of the body in an otherwise flat patch of light.

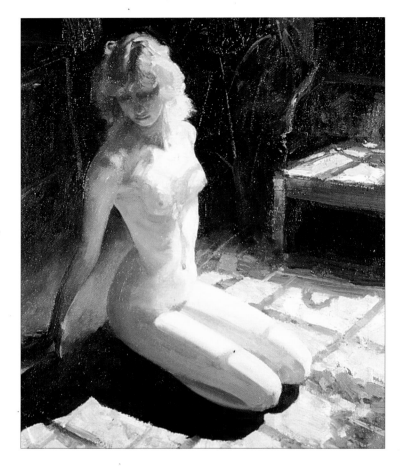

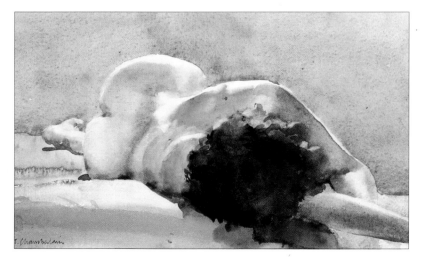

In the Spotlight
Trevor Chamberlain
18 x 25cm (7 x 10in)

Foreshortening occurs to some degree in most poses. Here the artist has solved the problem with clever use of colour and by painting what he sees, rather than what he thinks is correct. A splash of red in the foreground exaggerates the effect.

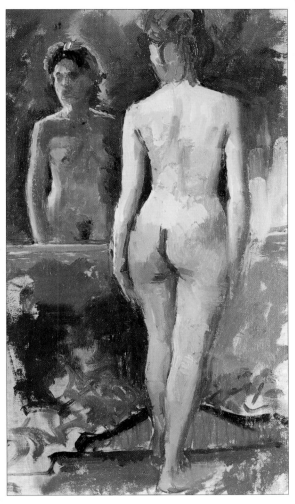

Nude By The Mirror

James Horton
25 x 15cm (10 x 6in)

This oil study is done on a canvas previously given a toned umber ground. The coloured ground acts as a mid-tone which shows through intermittently, giving the work a sense of harmony. It also speeds up the painting process and saves the artist from having to mix colours against a pure white background.

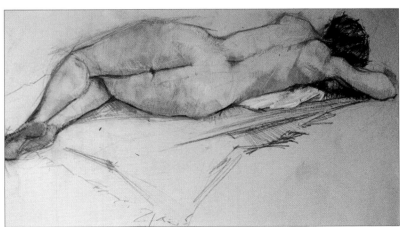

Life Study 2

Barry Freeman
76 x 56cm (30 x 22in)

There is a sculptural quality to this drawing. Done on toned buff-coloured paper which acts as a mid-tone, the figure is almost carved out of the paper using black and sanguine crayons. White chalk highlights give the finishing touches.

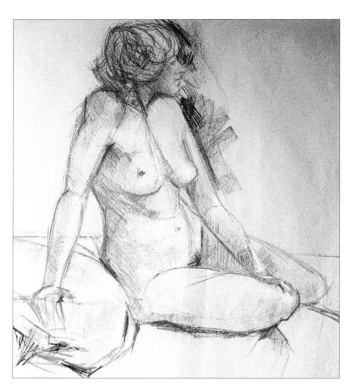

Life Study 1
Barry Freeman
76 x 56cm (30 x 22in)

Using three coloured chalks, the artist has drawn the model with a certain economy. He has made no attempt to cover underdrawing lines or construction marks, all of which add to the drawing's interest and give the viewer an insight into the creative process.

Standing Figure
Ian Sidaway
110 x 74cm (43 x 29in)

Careful hatching and cross-hatching with a range of graphite pencils create a full range of tones in this drawing. The graphite was fixed periodically, and an eraser was used to work back into the tone to modify and lighten areas.

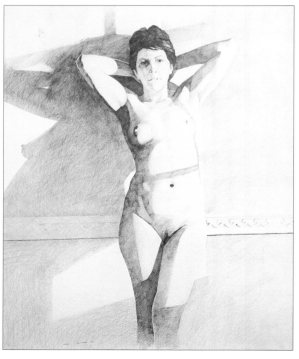

GALLERY

South Carolina Girl
Trevor Chamberlain
25 x 36cm (10 x 14in)

This well-posed watercolour has been painted using predominantly wet-in-wet washes. Both warm and cool colour washes have been delicately introduced to give the figure a sense of contact with her surroundings.

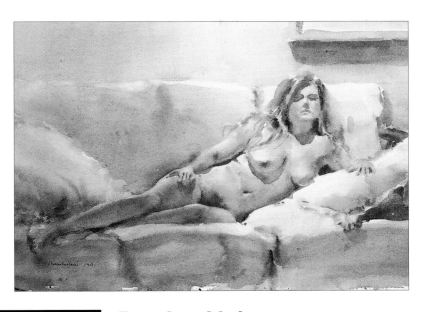

Evening Light
Charmian Edgerton
23 x 38cm (9 x 15in)

This pastel painting was made by the steady build up of pastel in broken strokes. Each layer allows a little of the previous layer to show through. Notice how the dark background is not a flat colour but built up with several different colours in much the same way as the figure.

Kim in a Green Scarf

Maureen Jordan
33 x 24cm (13 x 9½in)

A fluid line and sure sense of colour together with a clever choice of pastel paper all contribute to this delightful figure drawing. The artist has defined much of the outline, especially the right shoulder and breast, by working into the figure with the background colour.

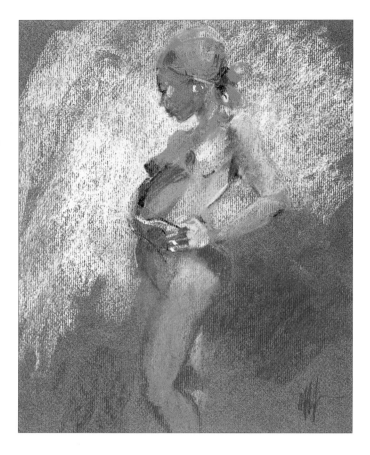

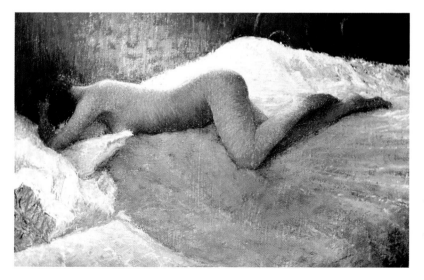

Blue Nude

Charmian Edgerton
20 x 38cm (8 x 15in)

This small pastel is delicately built up with strokes of pure cool colours placed next to each other, allowing the mixing to take place in the viewers' eye. There is little or no blending, which gives the work an intensity and brilliance that overworking could easily lose.

HELENA

This seated pose is a comfortable one and it should be possible for the model to hold it for a period of time quite easily. Mark those areas where the model touches the stool, so that after breaks it is easy for her to return to the same position. Dramatic lighting helps to accentuate the figure's form, adding interest and depth, and gives the student a little less, in terms of detail, to think about. The pose also allows the figure to be viewed from 360 degrees, making it possible to assess angles and shapes, and to select the best position to work from. The shapes seen around the figure, especially through the gaps made by the model's legs and the arms and legs of the stool, all help you to assess the precision of your work. This is achieved by looking at the negative space and shapes around the model and those created by her body, rather than just concentrating on the shape of the figure. A seated figure is more contained than a stretched-out figure, and makes far more interesting shapes, which should make it easier to relate one part of the body to another.

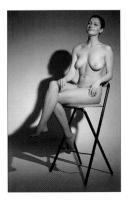 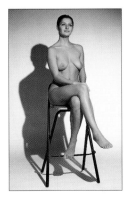 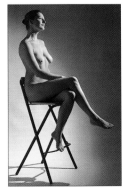

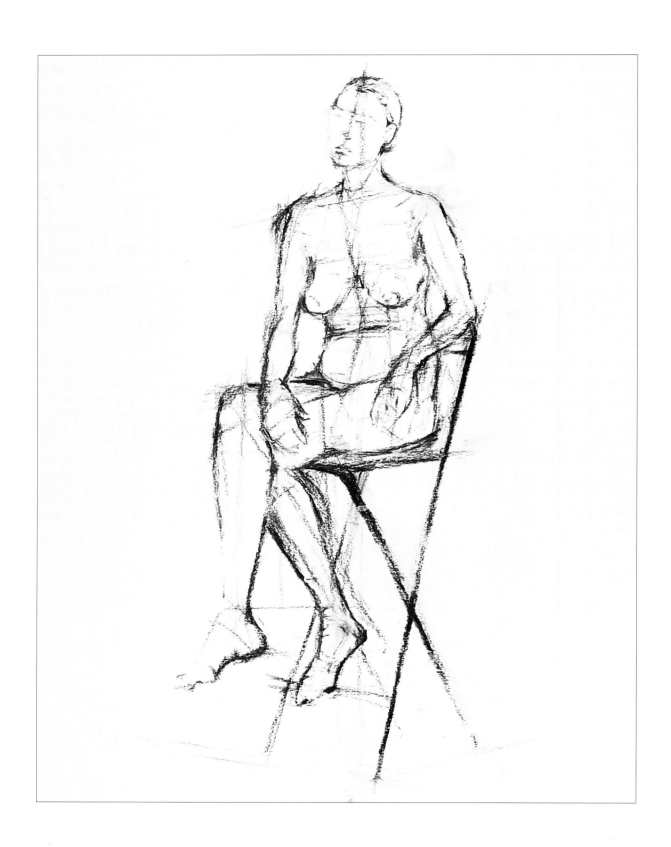

Project

1

CHARCOAL LINE DRAWING

Charcoal is a versatile and descriptive medium, which is perfect for showing the graceful flowing line that is a characteristic of the female nude. The medium allows a degree of detail but its very nature encourages a broader approach, forcing the artist to look at the figure as a whole. Charcoal has a beautiful line quality and by varying the pressure it is possible to make a wide variety of line thickness and degrees of tone. As charcoal can be messy, it would be wise to wear old clothes while you are working, and to protect the floor beneath the work area with newspaper.

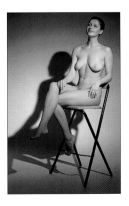

Charmian Edgerton
Helena – side view
36 x 25cm (14 x 10in)

HELENA – SIDE VIEW

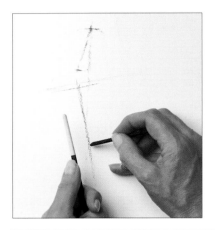

1.

Use a narrow charcoal stick to make two dots at the top and bottom of the paper, joined by a guideline to denote the figure's general extent and position. Look at the angle of the head using the straight edge of a paintbrush, held at arm's length, with your thumb at the figure's chin and the top of the edge at the top of her head. Bring the angle down onto the paper and mark in a light guideline. This will form the basis for the rest of the figure.

Materials and Equipment

• CARTRIDGE PAPER (ANY KIND OF PAPER CAN BE USED AS LONG AS IT DOES NOT HAVE A SMOOTH SURFACE) • VINE CHARCOAL STICKS IN A RANGE OF THICKNESSES • KNIFE FOR SHARPENING • OIL PAINTBRUSH, TO USE AS A STRAIGHT EDGE FOR MEASURING AND TO REMOVE LARGE AREAS OF CHARCOAL • PUTTY ERASER AND BALLS OF WHITE BREAD (FOR ERASING SMALL AREAS) • BOX OF TISSUES • FIXATIVE SPRAY

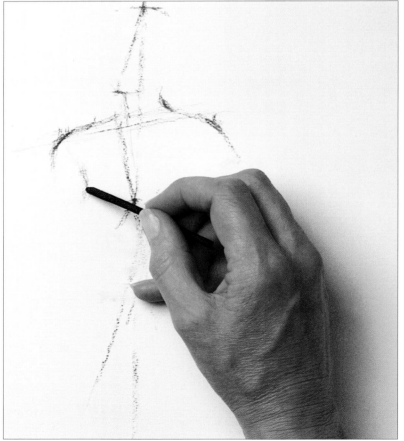

2.

Work down the figure, sketching guidelines for all of the body's key angles: shoulders, torso, hips and legs. Move the charcoal in the direction that the body moves.

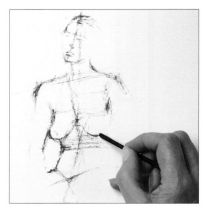

3.

Then start to flesh out the outline, working on either side of the central line. Pay attention to the spaces created by the figure, for example between the arm and the body, to assess the precision of your work.

4.

As you work down the figure, use the straight edge of a paintbrush again to assess the angles created by the body. Compare the proportions of the different parts of the figure; for example, the distance from the top of the breasts to the chin is roughly equal to that from the top of the head to the chin. Do not get too bogged down in measurement, or the drawing will start to look static.

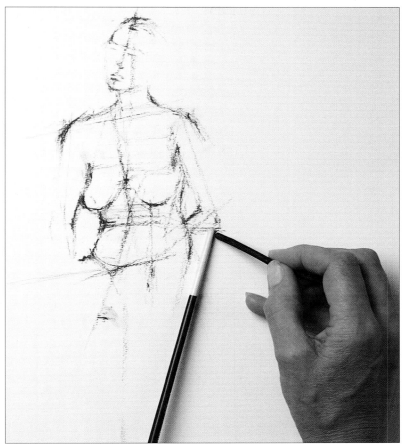

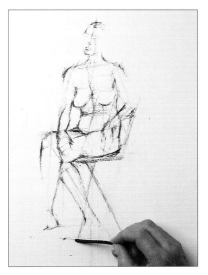

5.

Once the figure is almost complete, draw in the stool or chair, but beware of placing too much emphasis on this. Concentrate on the shapes and lines that the chair makes with the seated figure. Remember that the focus of the picture should be the nude, and the support should only really be hinted at in such a simple line drawing.

6.

In more difficult areas, for example in this drawing the hands and the angle of the arm resting on the chair, you may need to restate lines or adjust your initial framework to compensate for errors or movement by the model. Don't worry too much about detail, or erasing mistakes; remove lines only if they are making it difficult to redraw or if they are distracting to your eye.

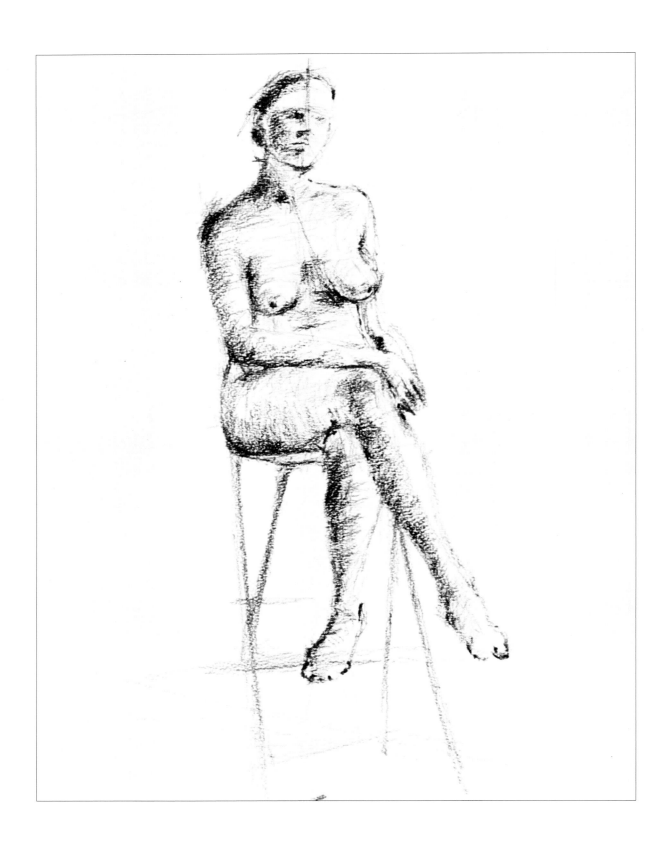

Project
2

GRAPHITE

Graphite sticks are available in different grades, ranging from HB to 8B. They are available either in pencil shapes coated with a plastic film to keep the fingers clean, or as thicker, short, hexagonal-shaped sticks. They can be sharpened like ordinary pencils. Graphite is used to produce a full tonal range and, by altering the angle at which the stick meets the paper, you can produce various thicknesses of line. With practice you can make a smooth transition from a thick to thin line in one uninterrupted stroke. Take care when using graphite, as it is relatively fragile and will shatter if dropped. When pressing hard, do not hold the graphite pencil or stick too far up the shaft. Shading, blending and erasing are carried out as with a conventional pencil.

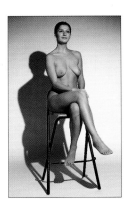

Charmian Edgerton
Helena – face on
25 x 18cm (10 x 7in)

HELENA – FACE ON

1.

Sketch out the body shape in line using the same principles to capture the basic angles and proportions as in Project 1. Work with a graphite pencil for this stage, as it is the easiest to control. As you sketch, look for the three main tones of the figure – dark, medium and light.

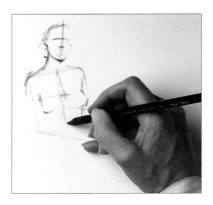

Materials and Equipment

• CARTRIDGE PAPER • SOFT (3B) GRAPHITE PENCIL • SOFT GRAPHITE STICKS • PUTTY ERASER • KNIFE FOR SHARPENING • FIXATIVE SPRAY

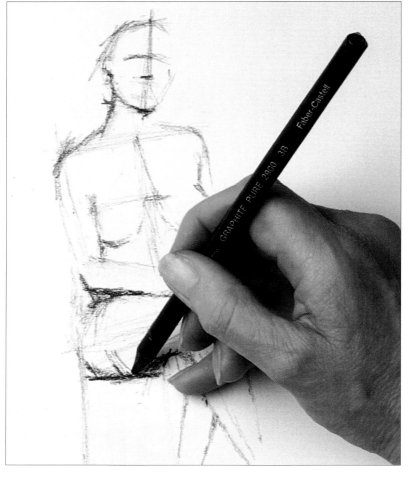

2.

Work down the figure, fleshing out the outline and adding contour lines and the areas of shadow which give the figure its weight – particularly where the body rests on the chair and the arm rests on the thigh.

3.

Choose one area of the darkest tone and shade this area, then go back over the figure adding the other areas of the same dark tone. Use the graphite stick for large areas. Draw with the graphite in the direction of the body's natural movement – across the thigh, then down the calf.

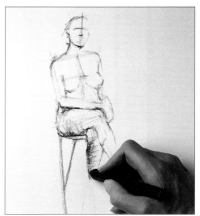

4.

Look out for the tonal shapes created on the body by the light. Observe how the differences in tone bring out the contours to give the sense of depth and volume. Applying mid-tones, working around the contours of the body, will lift the figure off the page and recreate this weight. For example, the tones and direction of the shading on the thigh help to define its shape and volume. Go back over the figure applying the areas of darkest tone, for example where the foot meets the stool. In the lightest areas, work very gently with the stick or pencil with small strokes. On the lightest edges of the figure, gently dot and dash in the outline to give the illusion of the body curving away from your eye.

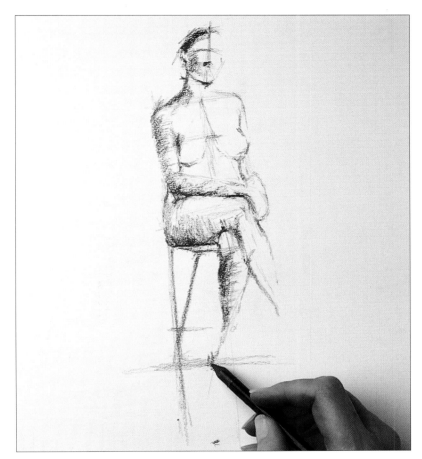

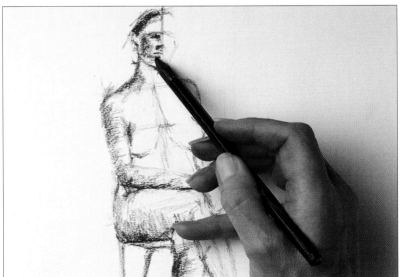

5.

Do not concentrate on the detail of the face, but search out the three tones – light, medium and dark – to give an impression of the features. Here, the right side of the face and the forehead are in strong light and are the lightest tone. The left-hand side of the face is in strong shadow and is made up mainly of the darkest and medium tones.

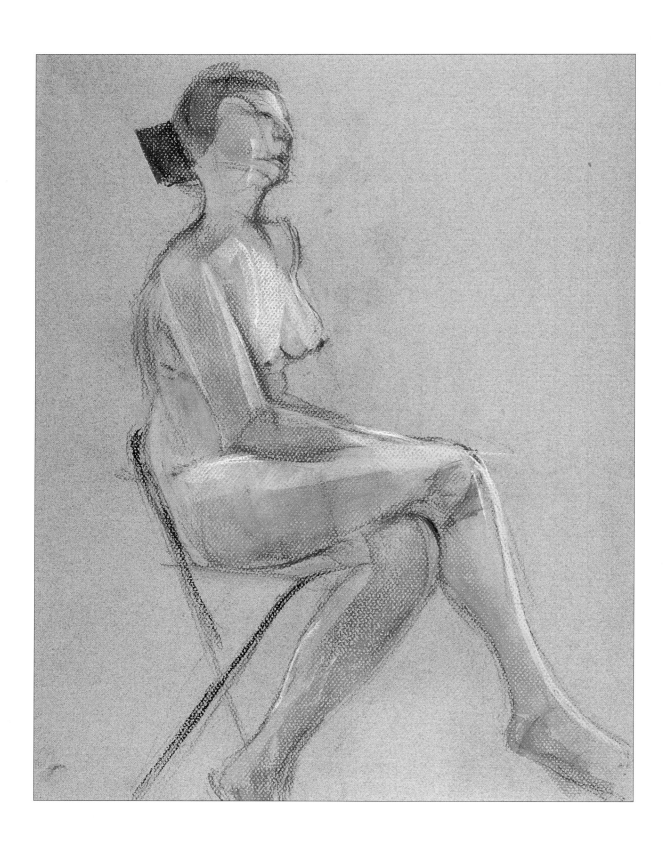

Project

3

HARD PASTELS

Pastels are dry, coloured pigment mixed with a binder and formed into sticks. One of the best known manufacturers is Conté, who make a range of hard pastels, which for the beginner can be easier to work with. These come as pastel sticks or as pencils (crayons). Coloured pastel pencils have many of the characteristics of charcoal but are easier and cleaner to use. Both sticks and pencils can be sharpened with a knife, allowing for fine line work and the building up of subtle hatched and cross-hatched transitions of colour and tone. However, these pastels smudge as easily as charcoal and they can be more difficult to erase. Pastels benefit from using a broader approach: begin lightly and gradually strengthen the drawing once you are sure it is correct.

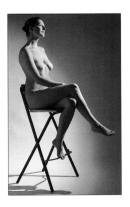

Frances Treanor
Helena – side view
56 x 41cm (22 x 16in)

HELENA – SIDE VIEW

1.

Using a spectrum blue pastel pencil, lightly sketch in guidelines to give the proportions of the figure as in Project 1. Work from the neck down, leaving the head until last. This is a working drawing, so don't be afraid to make mistakes.

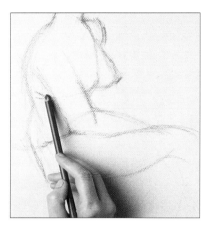

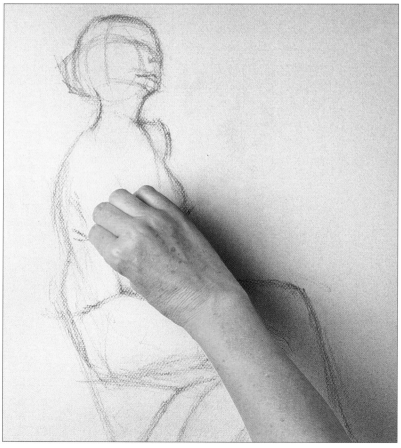

2.

Once you have completed the outline, look at the model to decide what the range of colours should be. In this case, the hair is the darkest, probably rating 8 on a scale of 1 to 10. Don't choose too many tones – keep it simple. Start with a salmon pink pastel stick, working from the top of the body down. Pinch the pastel between finger and thumb and use the side of the pastel to get a soft effect and cover broad areas.

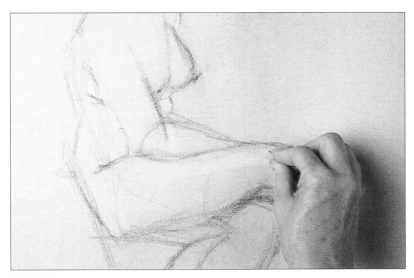

3▸

Continue to add the pink in other areas with the same basic tone as the neck and shoulder – down the back and along the thighs. Sweep the pastel along the curves of the body. Try to think of the method as "drawing with pastel" rather than simply "colouring in" the outline.

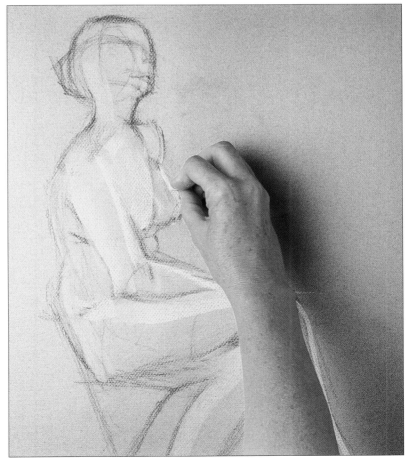

4▸

It's best to start with light tones and then add darker ones. Once you have applied the first, broad strokes, you can start to build up some tonal contrast – here burnt sienna is being applied over yellow. You're not trying to match the colours to life, but to render the tonal contrasts. Feel free to overlap colours or apply one on top of another and to blend them together.

5.
Continue to add colour – yellows and ochres are used here – but don't overwork the figure, keep it simple and work with the colour of the background paper to emphasise the highlights and shadows. Think about the direction of your strokes, following the direction that the body is taking in order to give a sense of the figure's shape and movement. Here, different strokes have been used to suggest the horizontal line of the thigh and the downward curve of the buttocks.

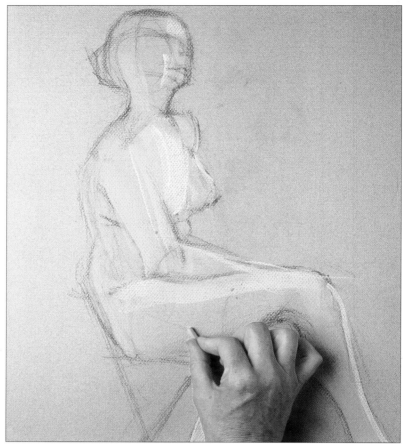

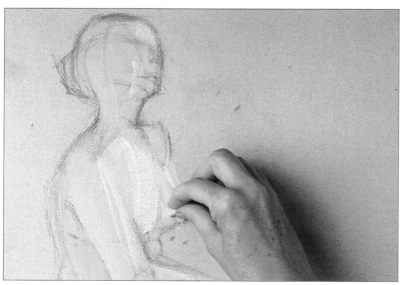

6.
Use the pale yellow pastel in the light-toned chest area. Sweep the flat side of the pastel around the curves of each breast to create a soft effect and to capture their form.

7.

As you work, you may find that you need to redraw. Don't be too concerned about erasing mistakes, unless they are distracting. If you do want to correct a mistake, use the torchon to blend the colour.

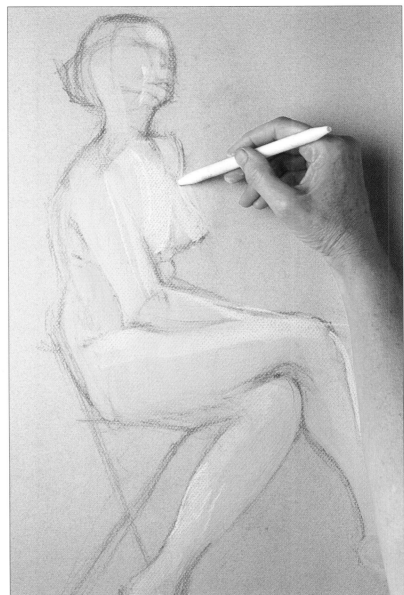

8.

Once you have added the main blocks of colour and got the tonal range right, including the highlights, you can add a minimum of detail using strong colours. Here a bold swathe of brown is used to delineate the hair, and burnt sienna for the nipples.

9.

Use your lightest tones sparingly, mainly for highlights. In this case, the figure is quite dramatically lit, giving very bright highlights, so some use of white is appropriate, but keep it to a minimum.

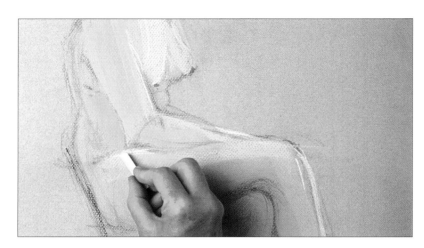

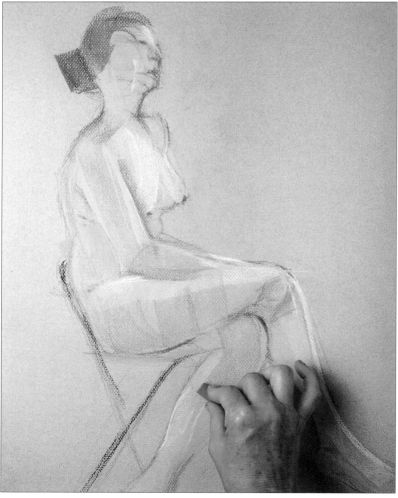

10.

Once you are satisfied with the overall figure, you can add a little detail to the face. You may also want to add some shading to give depth to the figure, but don't overwork it. Here, purple is used to strengthen the shading on the calves; a little has also been added to the hair.

Pose

2

L O U I S E

The second pose, again, is a comfortable one for the model and the addition of reading material has the effect of relaxing her even more. As with the first pose, the model can be approached from every angle and the strong lighting throws some interesting shadows. The main purpose of the pose is to present the artist with an outstretched figure. Parts of the body are seen to be much closer than others, and this presents the artist with problems of foreshortening where an outstretched foot, head or arm will look larger or smaller in relation to the rest of the body and out of proportion. For example, in a standing adult the head fits seven to eight times into the body, but when extreme foreshortening occurs this can be reduced to only three or four times. You will have to measure carefully and consider the body's perspective by breaking down the pose into simple blocks which follow perspective principles. Draw what you see rather than what you believe is correct, as this will help you to produce an accurate representation of the figure in front of you.

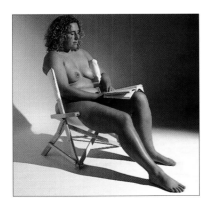
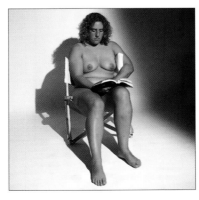
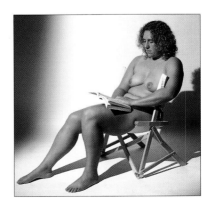

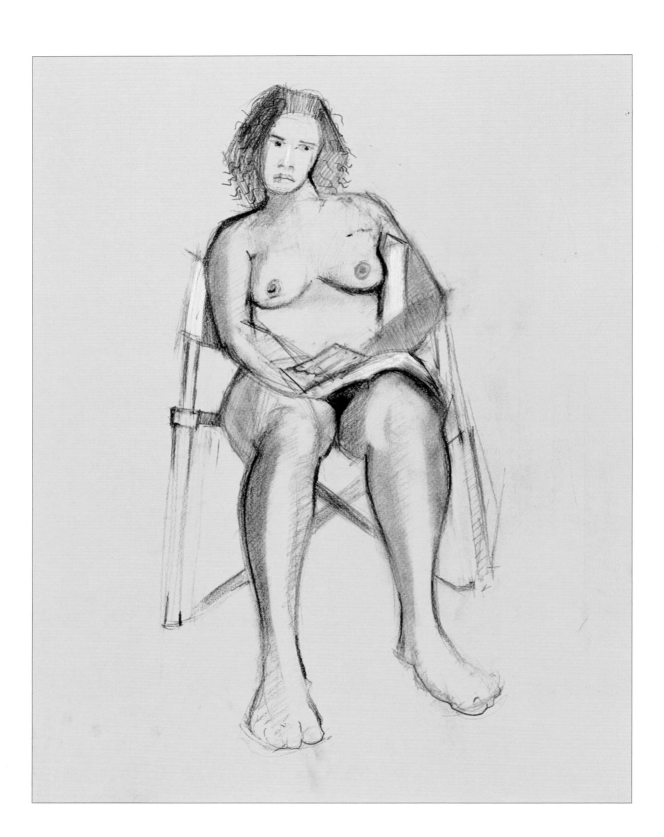

Project
4

SOFT PENCILS

The traditional pencil is one of the most widely used and versatile artists' tools. However, it is not always used to its true potential. Pencils range in hardness from 9H hard to 8B soft, and are capable of producing drawings of great beauty. A knife is the best means of sharpening a pencil, as the point can be made to suit the work at hand. Soft pencils – which range from B to 8B – become blunt with use so it is possible to make lines which vary in width, or to build up intricate shaded areas using hatched lines. Heavy scribbled shading can give way to subtle tone when it is smudged and spread with the fingers. Erasing can also be an important technique in the artist's repertoire, working back into the drawing to redefine lines, lighten tone and add highlights.

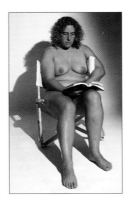

Frances Treanor
Louise – front view
36 x 25cm (14 x 10in)

LOUISE – FRONT VIEW

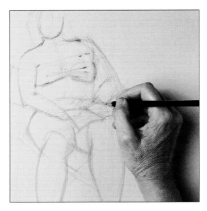

Materials and Equipment

- PALE ORANGE INGRES PAPER
- RANGE OF PENCILS: B, 2B, HB
- STICK OF COMPRESSED CHARCOAL • ARTISTS' PAINTBRUSH TO USE AS A STRAIGHT EDGE FOR MEASURING • PUTTY ERASER
- WHITE PASTEL PENCIL • KNIFE FOR SHARPENING PENCILS
- FIXATIVE SPRAY

1.

Use the HB pencil to sketch in the main lines of the figure, as in Project 1. Establish the basic proportions and position of the drawing on the page. With this position, the effects of perspective produce some quite extreme foreshortening. The feet and knees will appear quite large and the areas that move away from the eye, such as the thighs, will be shortened. This sketch needs to be fairly accurate, but don't worry about detail.

2.

Using the 2B pencil work down the figure restating the main outline. Screw up your eyes to help you to see the darkest tonal areas and use quite free hatching over these areas to start to give the figure form. Roughly indicate the facial features (the darker tonal areas and a few lines will do) and add the circles of the kneecaps (which are quite prominent in this pose).

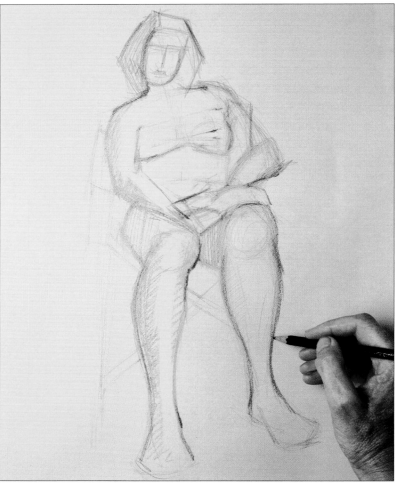

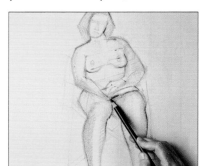

3.

Use the softest pencil (2B) to pick out the areas of medium tone and restate the main areas within the torso. Indicate the soft shadow beneath the breasts to give a more accurate rounded effect and emphasise the cylindrical shape of the thighs and arms.

4.

Because the pencil is soft you can use your fingers to blend the tones of the body to achieve a more flesh-like texture. As the form of the figure is cylindrical (which is especially pronounced on the legs and arms), the tone will be darkest furthest from the light source, gradually lightening to the highlights where the light hits the figure directly.

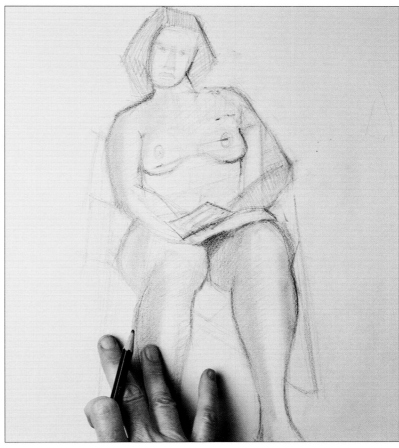

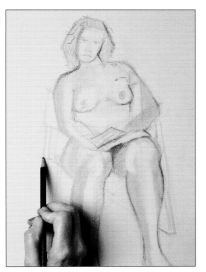

5.

Define the features of the face lightly using the 2B pencil – from straight on the nose is basically a triangular shape. Once the figure is almost complete, draw in the stool or chair more clearly with the 2B pencil. Pay particular attention to the position of the feet of the chair in relation to the model's feet so that she sits firmly on the ground. Also make sure that the effects of foreshortening in the figure are not contradicted by the relative position of the chair legs. Look at the shapes and lines that the chair makes with the seated figure. Remember that the focus of the picture should be the nude, and the chair should only really be hinted at.

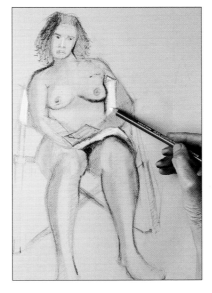

6.

Add final details to the hair, hands and feet if necessary. Use the putty eraser as a drawing tool to remove colour from the highlighted areas of the body. Finally, use a white pastel pencil to pick out the chair detail.

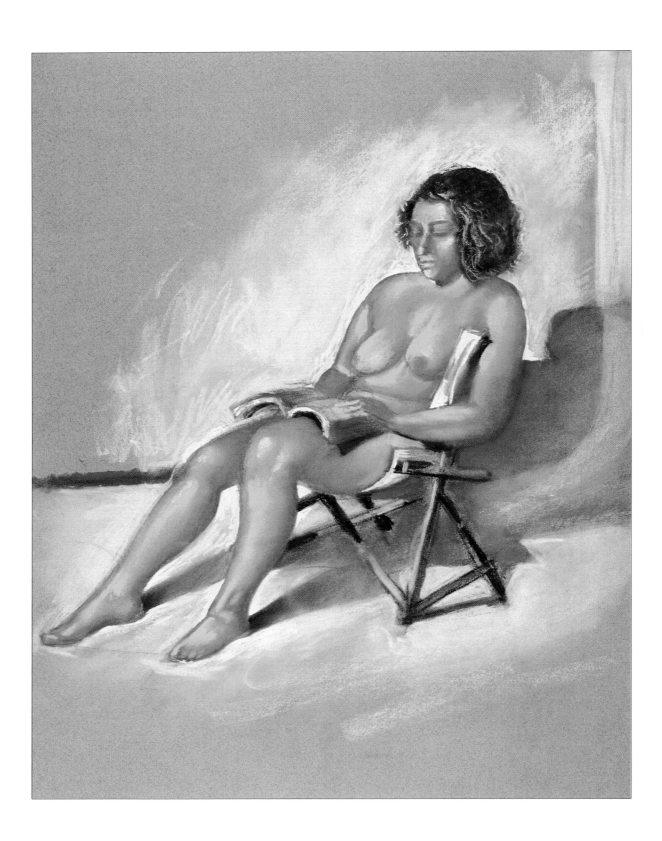

Project
5

SOFT PASTELS

Pastels have a brilliance and jewel-like quality, which is almost sensual, and they hold a unique allure for the artist. Using pastels is similar in many ways to working with oils; indeed pastel drawings are often described as paintings. Soft pastels are available in a wide range of colours, tints and hues in order to lessen the need for unnecessary mixing. Unlike paint, the sticks are mixed on the paper or board support, or by placing pure colour tints next to one another so that the mixing takes place in the eye of the viewer. Pastels are easy and straightforward to use, but good results are not so easy to achieve. Practice and a sure approach will help. Pastel paintings are delicate and will need to be sprayed with fixative in order to prevent smudging.

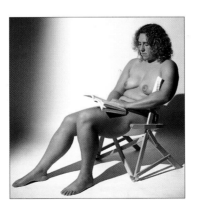

John Barber
Louise – three-quarter view
25 x 18cm (10 x 7in)

LOUISE – THREE-QUARTER VIEW

1.

Sketch out the body shape and the shape of the shadow around the figure, using a red pastel pencil, which will give you more control than the pastel sticks. As you sketch, look for the three main tones of the figure – dark, medium and light. In the areas of darkest tone use the torchon like a paintbrush and your finger to turn the lines of the sketch into areas of tone.

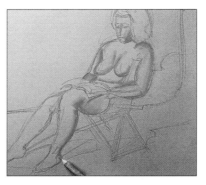

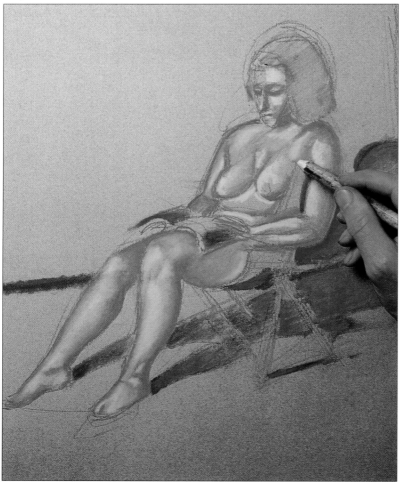

2.

Use the flat side of a purpley-blue pastel for the areas of cast shadow around the model and on the book. Blend to achieve a flat tone. It doesn't matter if the original red starts to blend in. Then use a light pink pastel to pick out the areas of the lightest flesh tone and blend with the torchon.

3.

Add white to the chair arm and to the book, then with a dark brown pastel, accentuate the darkest areas of shadow on the figure. These occur where the arm rests against the chair, where the cast shadow meets the feet, under the book and on the chair legs. In the same colour, block in the model's hair.

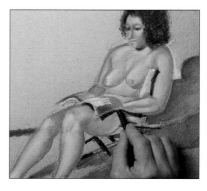

4.▸

Use a white pastel pencil to bring out the background around the figure, making any alterations to the outline. Notice the differences in contrast with the background around the figure, where the edges of the body almost blend into the background in places, but stand out very harshly in others. Adjust the shadow to show any changes in the intensity of the cast shadow and blend with your fingers. Add yellow highlights to the chair legs.

5.▾

Use yellow, brown and white to add colour, texture and highlight to the hair; follow the hair lines to define the shape of the skull. Sharpen the white at the edges, using white gouache and a soft sable brush.

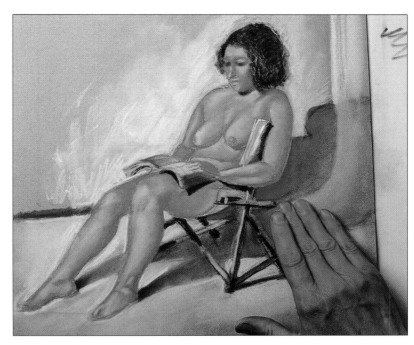

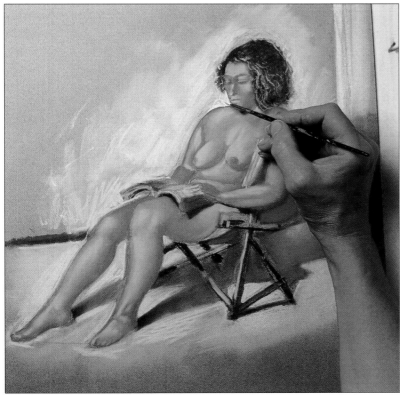

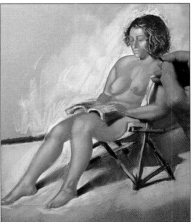

6.▴

Finally, use the brush and gouache to pick out the very lightest areas on the arm of the chair, and on the model's face where the light hits the cheek and forehead. Avoid making the brushwork too obvious. This final touch should be very subtle. Do not attempt to make the face too detailed, otherwise the head will dominate the picture as a whole.

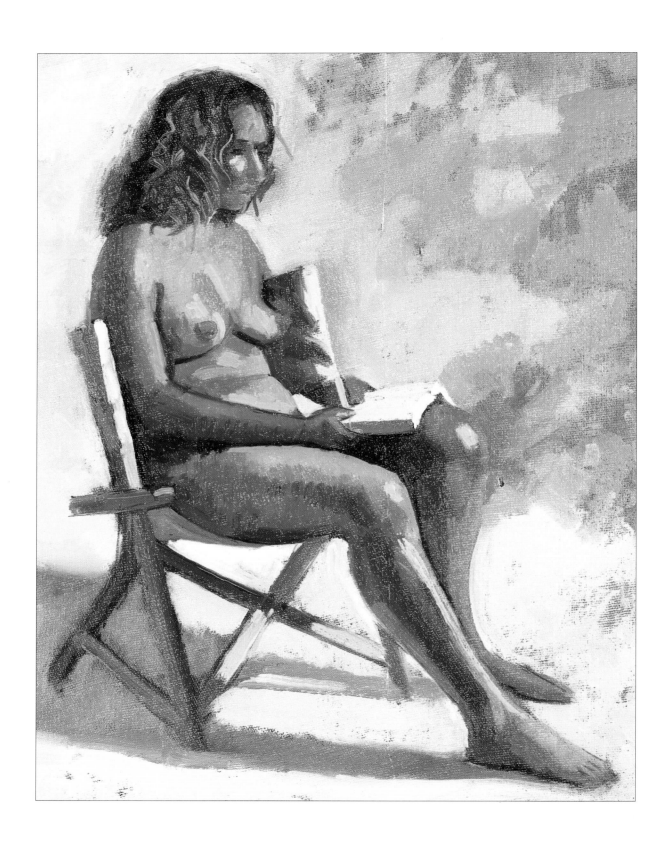

Project
6

OIL PAINTING

Oil paints are unmatched when it comes to versatility and depth of colour. The medium has a long tradition and it is possible that more artistic works are painted in oil than in any other medium. Contrary to popular belief, oil paints are surprisingly easy to use and the range of techniques and means of application are vast. Paint can be applied with a brush, a knife, the fingers, rags or even rollers. It can be trowelled on thick or applied in thin transparent glazes, and if the result is considered unsatisfactory, it can be scraped or wiped off. The main principle to apply is to work "fat over lean". This is done by using paint mixed with turpentine or white spirit thinners and little oil in the initial layers, and adding oil only to the mixes in the final or top layers of paint.

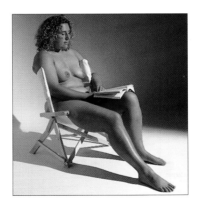

James Horton
Louise – side view
56 x 41cm (22 x 16in)

LOUISE – SIDE VIEW

1.

Use a weak ultramarine to sketch the outline of the figure in order to place the image correctly on the board and to establish the proportions and lines. Do not worry about accuracy because the work can easily be adjusted as you go and the lines will be obliterated by the overlaid paint. Once you are happy with the basic composition, paint in some of the background using white and ultramarine.

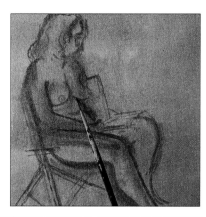

Materials and Equipment

• PRIMED CANVAS AND BOARD (SEE PAGE 23) • PALETTE OF OIL PAINTS: BLACK, ULTRAMARINE, ALIZARIN CRIMSON, CARNELIAN RED, CADMIUM RED, BURNT UMBER, RAW SIENNA, YELLOW OCHRE, CADMIUM YELLOW, TITANIUM WHITE • WOODEN PALETTE • SEVERAL ARTISTS' PAINTBRUSHES IN NYLON, BRISTLE AND SABLE, RANGING IN SIZE FROM 2 TO 8 • PALETTE KNIFE • TWO CLIP-ON DIPPERS TO HOLD SOLVENT AND MEDIUM • WHITE SPIRIT FOR WASHING BRUSHES • RAG

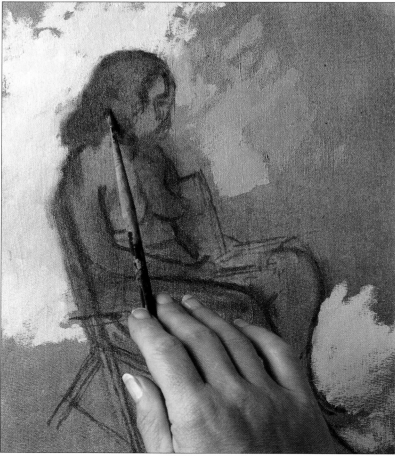

2.

Starting with the model's hair, use a thick brush to put the basic colour building blocks in place, using a mix of yellow ochre, cadmium red and black. Try not to add too much detail at this stage – think of it as the first step in putting the colour in place.

3 ▸

Mix a basic flesh colour with raw sienna, cadmium red, white and burnt umber, and start applying it in broad blocks; picking out three tones, light medium and dark. Try to build up the figure as a whole, rather than trying to finish any one section in detail. Then, begin to work on the figure's limbs. Use the side of a palette knife to scratch at the paint on the arms and legs to develop the highlights. There is no need to add too much detail at this stage of the painting.

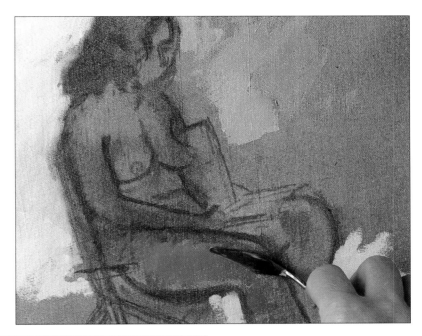

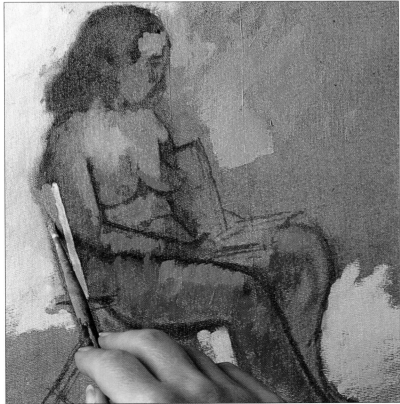

4 ◂

Now develop the shape of the chair. Begin to fill in the shape with a combination of yellow ochre, burnt umber and ultramarine, to give it more definition. Pick out the highlights with white. As before, do not worry about detail.

5.

Use a rag to remove any areas that you are not happy with or any accidental blobs of colour.

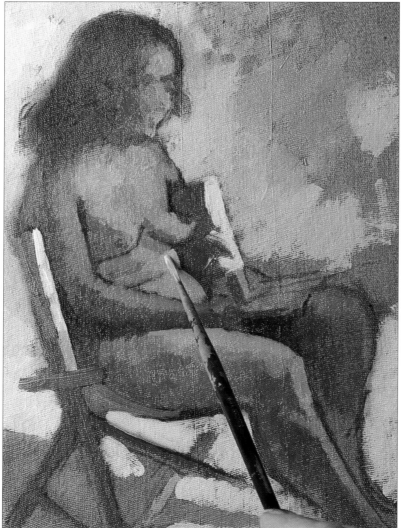

6.

Start to look in more detail at the subtle colour changes over the model's body, such as the stomach. With one of the medium brushes, revisit small areas within the main colour blocks, making small adjustments to colour and tone, using the three flesh tones. Skin is not simply one flat colour; it varies enormously over the body's surface and with the effect of light.

7.

Taking the finest brush, use white and cadmium yellow to build up layers of colours through the hair to give it texture. As the hair colour will change in the light, aim for the correct balance of colours and realistic tonal relationships, rather than an exact replication.

8.

Using a fine brush, continue with the development of the chair. Sharpen the colour of the background in relation to the chair in order to bring out its shape.

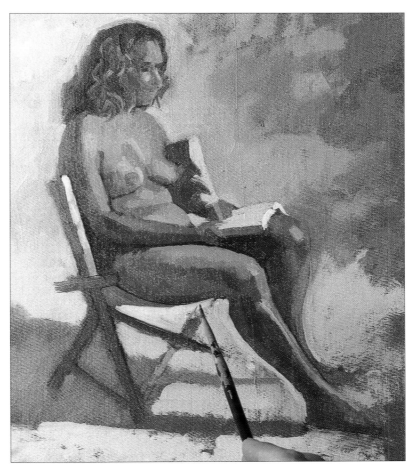

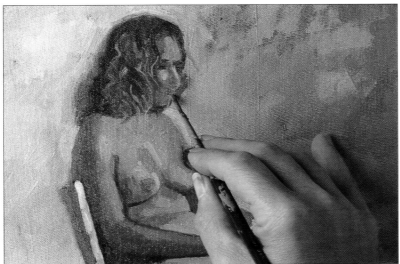

9.

Concentrate on the head, first by adding colour to the hair. Then, using the finest brush, start to pick out some of the details on the face, paying attention to the eyes and nose. For the mouth, use a mix of cadmium red and raw sienna.

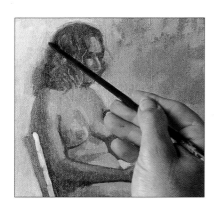

10.

When the colour on the head is complete, use the end of a brush to scratch away at the back of the hair to soften the line and give the hair texture. At the same time, use the back of the brush to remove any small splashes of paint.

11.

As the painting nears completion, add the finer details to give a final polish. Bring out the tonal values of the figure and background by making small adjustments to the colour in critical areas such as the knees.

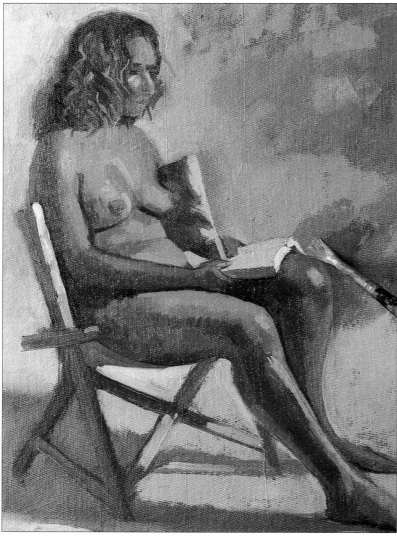

Pose

3

S ARAH

The straightforward standing figure may at first seem to be the simplest to draw or paint, but this is not necessarily the case. Here, the model is lit from the side to accentuate the tonal contrast from light to dark, which means that much of the tone which defines the form could be inferred rather than accurately represented. The main problem with drawing or painting the standing nude figure is achieving the correct balance and distribution of weight. Working from a vertical line, either imagined or actually drawn, will help you to position the figure correctly. This line should be positioned to run vertically from the centre of the neck to the floor as this represents the body's centre of gravity. Correct measuring of proportion is critical in order to prevent the figure appearing too short or long, and correct use of this vertical line will prevent the figure seeming to fall over. Make frequent reference to the shapes around the figure to check and reassess the accuracy of your work, and readjust as you go.

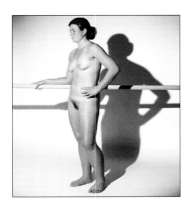
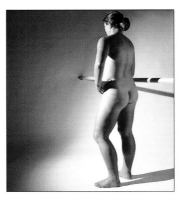
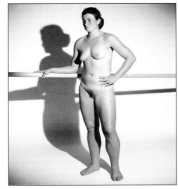

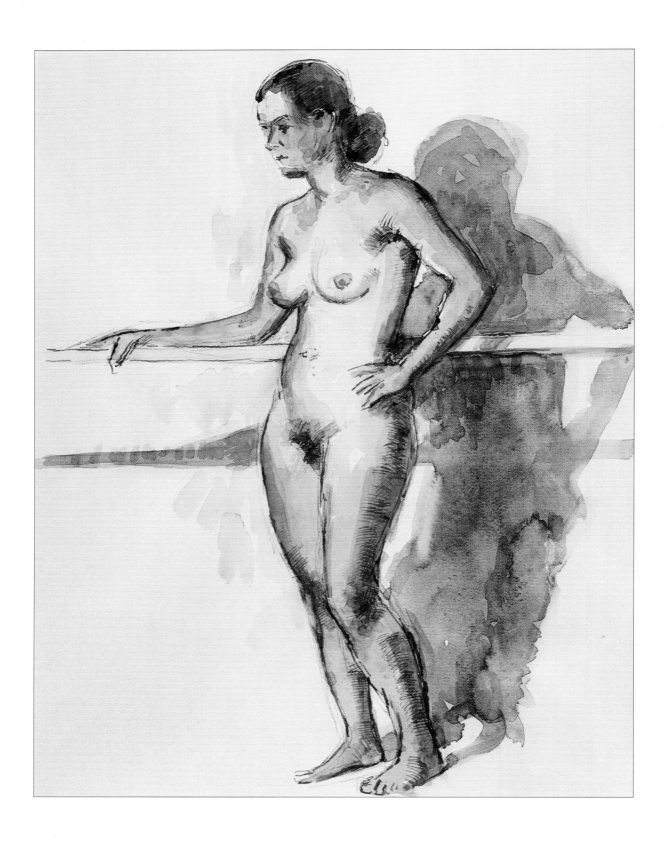

Project
7

PEN AND WASH

Using pen and wash can be deeply satisfying. The pen can produce beautiful line work of varying thickness and solidity, or hatched, cross-hatched, broken, dotted, ticked and smudged lines. Diluting the ink with water extends the possibilities even further. Water-soluble ink washes extend the medium's potential, enabling you to add solid blocks of line and tone. Corrections are difficult to make in pen and wash and are best incorporated into the work. Any mark should be considered carefully and, to this end, a light pencil drawing can be of assistance as a guide. This will enable you to concentrate on the pen work, which can be suprisingly varied. The pen and wash should work together, rather than the wash being used simply as a means of "filling in"

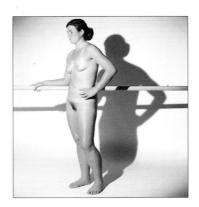

James Horton
Sarah – three-quarter view
36 x 25cm (14 x 10in)

65

SARAH – THREE-QUARTER VIEW

Materials and Equipment

• CREAM WATERCOLOUR PAPER
• HB PENCIL • WATERCOLOUR
PALETTE: CADMIUM RED, YELLOW
OCHRE, COBALT BLUE, PAYNE'S
GREY • RANGE OF SMALL, SABLE
ARTISTS' BRUSHES • WATER
• BROWN INK • TWO OR THREE
GOOSE QUILLS CUT INTO A
POINT • FINE METAL-NIBBED
DIP PEN

1.

Sketch the basic lines of the figure using an HB pencil. Do not include any shading or form, as the pen and wash will be used for this. Using cadmium red and yellow ochre, with a touch of cobalt blue for the darker tones, mix one or two basic skin colours and start a watercolour wash across the figure with a small brush. Aim to indicate only the broad areas of the main variations in tone and colour across the flesh. Use very transparent layers of paint.

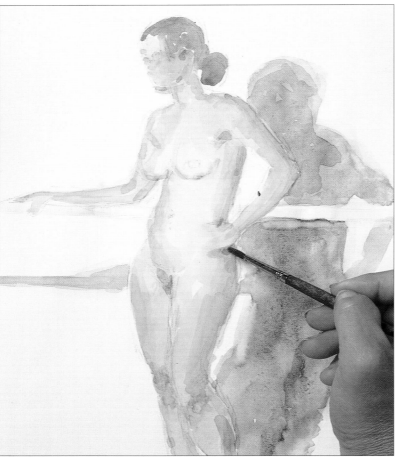

2.

Build up thin layers of colour, to indicate changes in the depth of tone. Pick out the shapes of the shadows on the body by using the darker skin colour. Then using a grey-blue wash and a larger brush, add the background shadow.

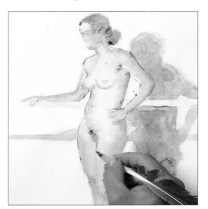

3.

Wait for the paint to dry, then use a quill and brown ink to restate the main lines and add some detail to the face and hands. The quill is not a totally controllable tool and the blotches and variations in line add to the spontaneity of the picture.

4.

Use fairly light hatching in the areas of darkest tone to accentuate the form of the figure and changes of plane, for example around the knee cap where the leg angle changes. Keep the hatching fairly loose so that the ink does not dominate the picture and give the impression of a "coloured-in" line drawing.

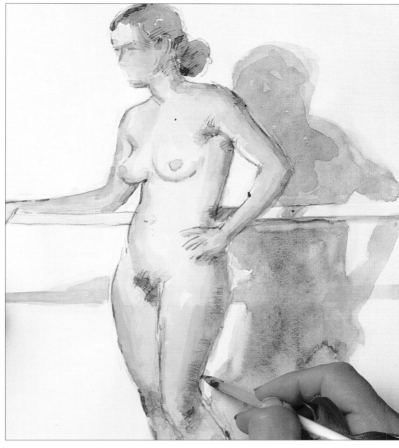

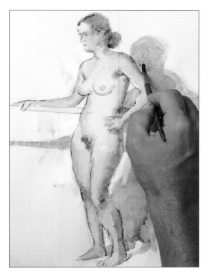

5.

Using a small brush, mix Payne's grey with a little cobalt blue and build up the changes in depth of the background shadow. The shadow should be slightly darker around the figure to "lift" the nude off the page and to indicate the space between the figure and the background.

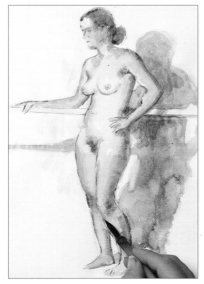

6.

Finally, use a fine metal-nibbed dip pen to restate any fine lines and the finer detail around the face and head. The position of the ear is particularly important as it indicates the angle of the head, but do not try to achieve too much detail.

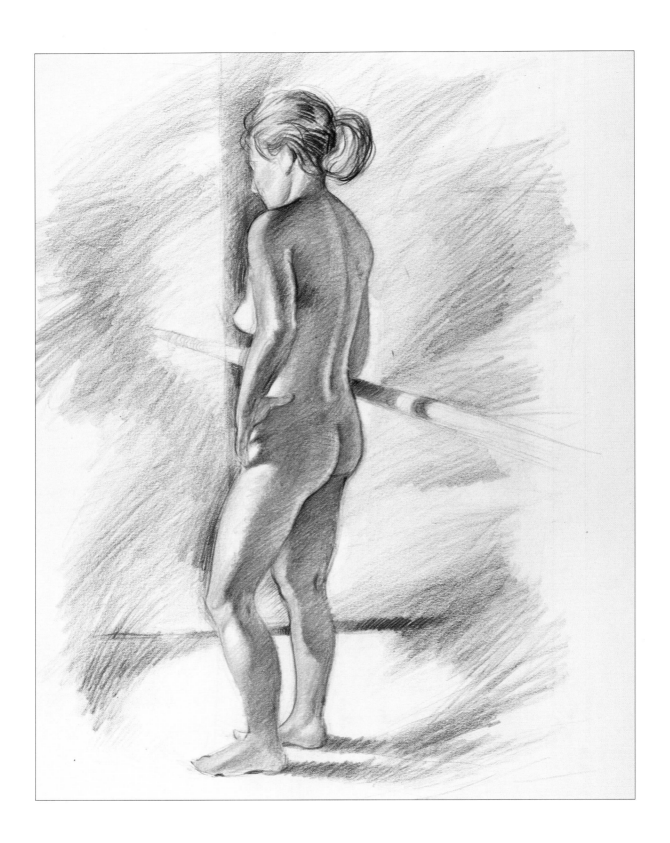

Project
8

COLOURED PENCILS

Coloured pencils give the tight control found with ordinary lead pencils. The techniques that can be achieved using coloured pencils far outstrip the traditional image of them as children's playthings. Although they are capable of producing loosely scribbled expressive work, they can also produce very subtle images of almost photographic quality. The range of marks that can be made is similar to graphite pencils, but because they are made from pigmented wax they can be more difficult to erase. Coloured pencils are mixed either by layering one colour over another, or by laying colours close to one another so that when viewed from a distance they are mixed in the eye of the viewer.

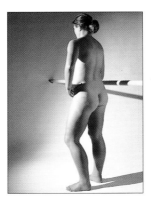

John Barber
Sarah – rear view
25 x 18cm (10 x 7in)

SARAH – BACK VIEW

1.

Make a preliminary sketch, using a reddish brown pencil, to get the proportions and position of the figure correct. Make sure that the feet are firmly established in relation to each other. The shin of the leg that is taking the weight should be vertical. Block in the head and mark the position of the left ear. Then refine the sketched outline.

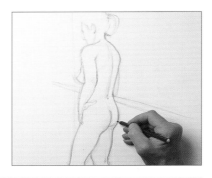

Materials and Equipment

• LANA WATERCOLOUR PAPER (A3) • SELECTION OF COLOURED DRAWING PENCILS: RED-BROWN, PALE ORANGE, PALE BLUE, PURPLE, LILAC, GREY, BROWN, DARK GREY • KNIFE FOR SHARPENING • RUBBER ERASER • ADHESIVE PUTTY

2.

Notice which parts of the body turn away from the light and draw a line from the top of the head to the feet, splitting the figure into a basic dark side and light side. The shape of the cast shadow tells a lot about the form. For example, the shape of the shadow where the hand meets the hip shows that there is a space between the arm and the body.

3.

Using a loose hatching technique, block in the area of darkest tone all across the body. Do not try to show the changes in form of the body. Concentrate only on the patterns of light, shade and tone in order to keep the emphasis on the fluid lines of the nude.

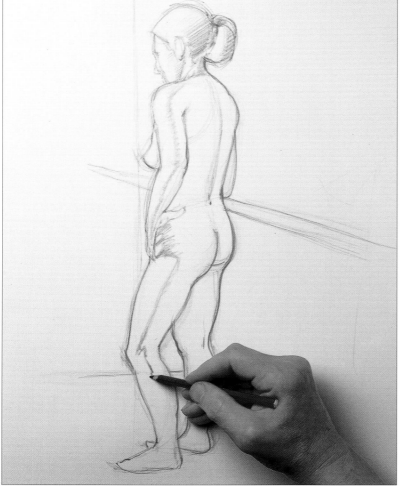

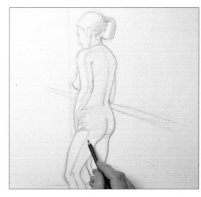

4.
As you work, continually readjust and restate the lines of the figure. Each stage of work is likely to draw your attention to areas of inaccuracy in the drawing. Use an ordinary pencil eraser to remove any inaccurate lines.

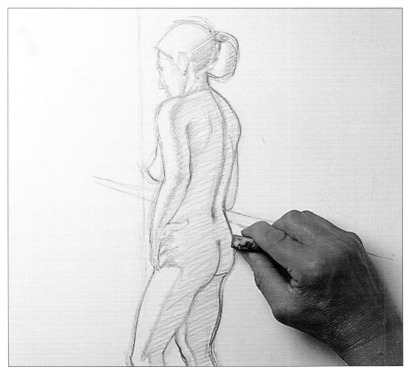

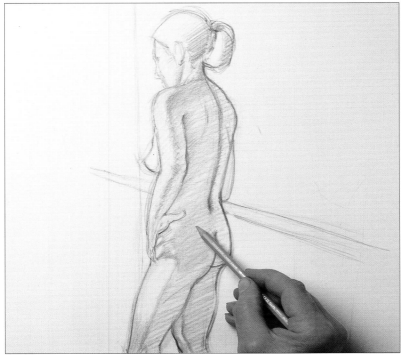

5.
Change to a pale orange and hatch in the mid-tone areas, but continue into the shaded areas, to keep the continuity of colour across the skin.

6.

Once the basic three tones have been established, look at the figure again and using the pale orange start to elaborate on the changes of tone across the body, darkening and deepening the colour where appropriate. For example, the edges of the areas of shadow often give the impression of having a deeper, richer tone and colour. This will start to bring out the form of the body.

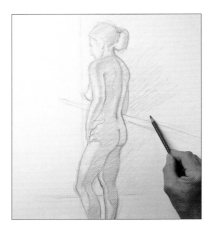

7.

Use pale blue and purple pencils to hatch in the background. To achieve a continuous tone, use the side of the pencil. The background will give the picture more depth and will bring out the leading edge of the figure because the cool colours contrast with warm flesh tones. In some areas around the edge of the figure the contrast will be more marked than others. For example, along the model's back the tone of the wall and the figure are much closer than down her front.

8.

Use a purple pencil to add the cast shadow. Because the model is well lit, this will be quite an intense colour with definite edges. The angle of the shadow tells you where the light source is (as does pattern of light and tone over the figure). The shadow can be drawn to denote the texture and angle of the background. It can also be used to judge whether the model has taken up the correct pose after breaks.

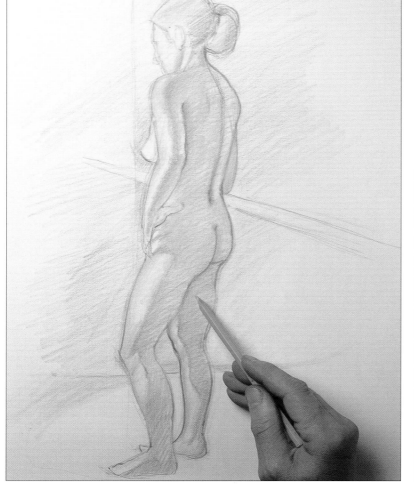

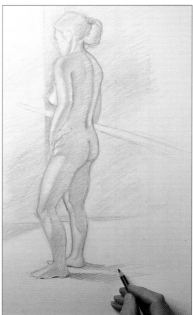

9.

Start to add the final touches. Bring out strength of colour in relation to the background by adding the reddish tones of legs, emphasising the strong shadow edges. If areas begin to look too "hot", tone them down with a cool lilac hatched over the top. Add the shadows on the barre using grey and brown. These shadows indicate the gap between the furthest arm and the body, even though this cannot actually be seen in this view. Then using a piece of adhesive putty, moulded into a point, gently dab off some of the colour on the highlighted areas of the body, for example, on the breast, where the hand meets the hip, and down each side of the spine.

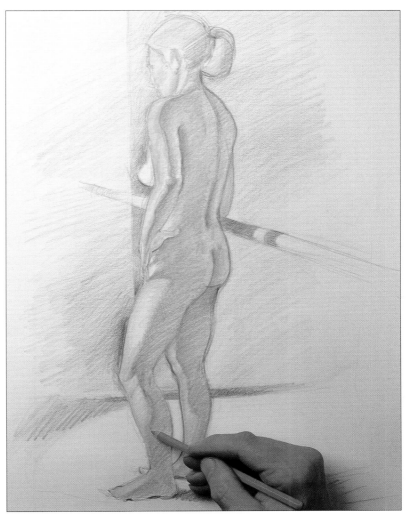

10.

Finally, use the brown pencil to pull together the figure with more line work, and using the same colour, add the final detail to the hair. Look carefully at how much of the face is actually showing: about sixty per cent of the head is covered by hair. Use a darker grey to bring out the face, and the front of the shoulders. Do not overdo the hair and face or the head will dominate the picture, and this is not intended to be a portrait, but a celebration of the female form in its entirety.

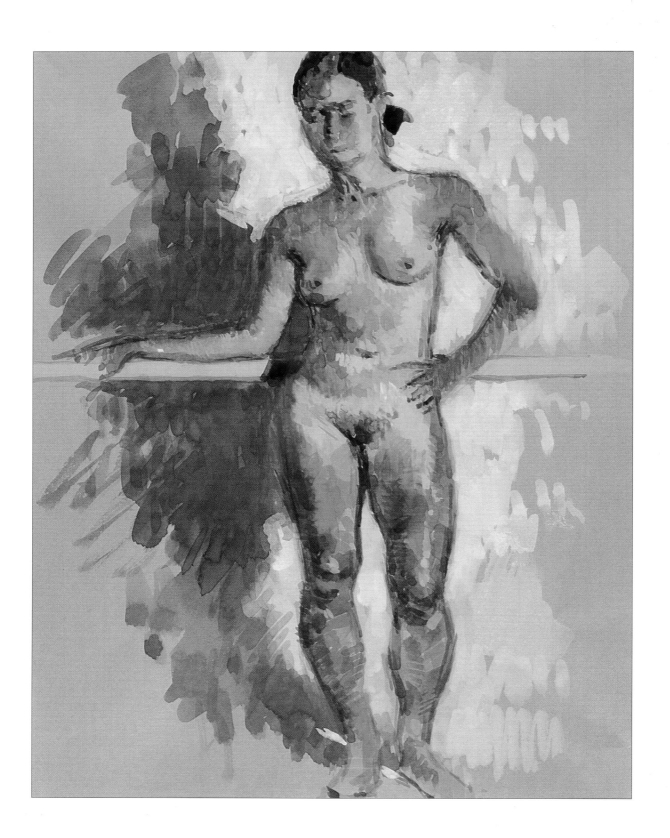

Project
9

WATERCOLOUR

Water-based mediums have been in use longer than any other. The nature of watercolour – its unpredictability – is part of its attraction. The best work combines simplicity, spontaneity and the elusive Inner Light, which is the main characteristic so evident in pure watercolour technique. This is achieved by allowing the paper to reflect light back through the thin washes of paint. It is for this reason that watercolour paintings are usually painted on very light papers. The medium perfectly suits the subtle gradations of colour and tone seen on the nude form. Its application can be fast and loose, with colours and washes being allowed to mix on the support, or worked in a more considered way, "wet on dry", each layer altering and qualifying the next.

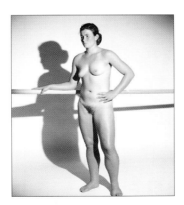

James Horton
Sarah – front view
56 x 41cm (22 x 16in)

SARAH – FRONT VIEW

1.

Using a small brush and a thin wash of yellow ochre and cadmium red, sketch the figure outline. Do not worry about details. Work on getting the axis down the torso correct and the feet in the right place in relation to each other. Paint in some of the background using Payne's grey and yellow ochre. Use a very pale grey, mixed with a little white gouache to make it more opaque, and darker grey for the shadow. This will eventually fill the whole paper.

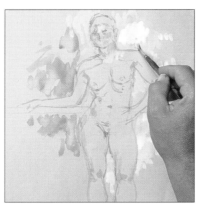

Materials and Equipment

• GREY INGRES PAPER WITH GRAINED SURFACE, MINIMUM A3 SIZE • BOARD TO ENSURE AN EVEN SURFACE TO WORK ON • WATERCOLOUR PALETTE: ALIZARIN CRIMSON, CADMIUM RED, CADMIUM YELLOW, YELLOW OCHRE, ULTRAMARINE BLUE, BURNT UMBER, PAYNE'S GREY • THREE SMALL SABLE ARTISTS' BRUSHES • WATER • WHITE GOUACHE • RAG OR TISSUE

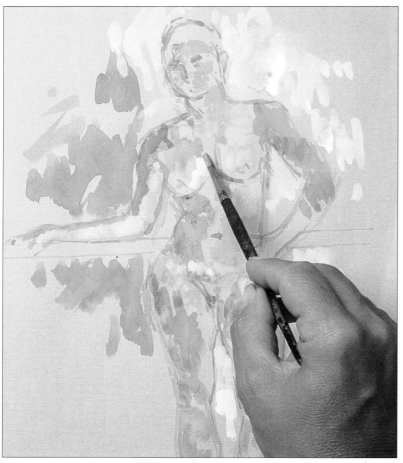

2.

Mix a basic flesh colour with cadmium red and cadmium yellow; this can be mixed with ultamarine to create the darker skin tones. Go across the body with a thin covering of colour first and then start to pick out the tonal changes, sounding out main colour and tonal differences in a broad way.

3.

Once the basic tonal differences have been established over the figure, use burnt umber to paint the hair. Bear in mind that the head is a dome shape so there will be differences in tone even within the hair. Because the model is lit from the front, the sides and back of the head are darker, with a lighter area across the front and top. Using a darker mix of the background grey, bring the shadow behind the model into a sharper focus, working the colour right up to the figure. This will start to bring the figure out from the page, indicating the space between the model and the wall behind. The angle of shadow also gives information about the direction of the light source and its intensity.

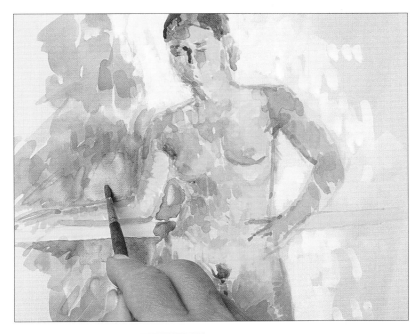

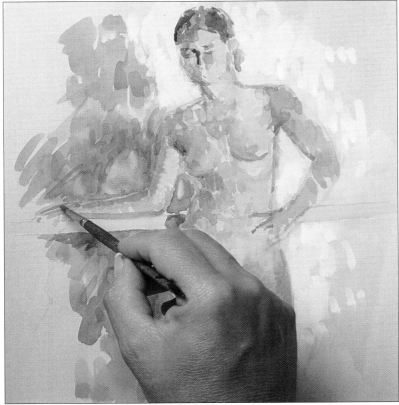

4.

The addition of the background colour will probably bring your attention to areas of the figure's edge that you want to alter and correct. Here, the forearm along the barre was thinned slightly by painting the background up to a new edge.

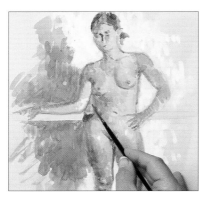

5.

Define the modelling on the body with the skin colour. Bring out more subtle tonal differences by mixing with Payne's grey and burnt umber. Use the darker, more brownish skin tone down the left hand side of the figure to "carve" it out of the paper. Add light pinks to the areas where the light hits the paler skin of the abdomen and breasts. Contrasting thin and thicker layers of colour will help to bring out texture and tone.

6.

Finish by adding the finer details of the facial features, using the smallest brush. However, do not try to create an exact portrait. A suggestion of the main features and the pattern of colour and tone will suffice.

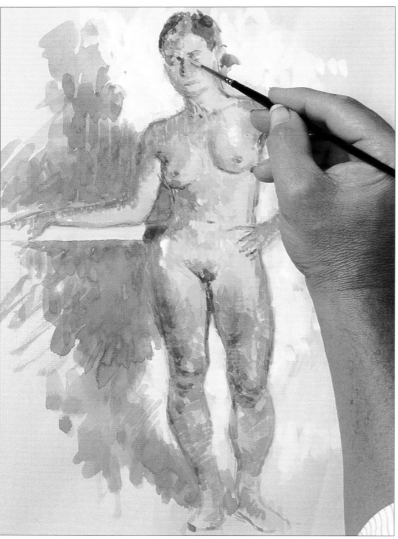

INDEX

PICTURE CREDITS
The author and publishers would like to
thank the following for permission to
reproduce additional photographs:
The Bridgeman Art Library: pages 6–9
Also to Bernard Thornton Artists Ltd
Index compiled by: Sue Bosanko